ARTBURN
BY ROBBIE CONAL

RDV BOOKS

New York

Published by RDV Books/Akashic Books
©2003 Robbie Conal

ISBN: 0-971920-61-3
Library of Congress Control Number:
2003105119
All rights reserved
Second printing
Printed in China

RDV Books
130 Fifth Avenue, 7th Floor
New York, NY 10011

Akashic Books
PO Box 1456
New York, NY 10009
Akashic7@aol.com
www.akashicbooks.com

DEDICATED TO

DEBBIE ROSS,
SUE HORTON,
AND BOOM BOOM*

TABLE OF CONTENTS

PREFACE

SATIRICAL POLITICAL ART HAS ALWAYS BEEN

the weapon of the powerless.

The restored Bourbon monarchy of France after the Revolution and the Napoleonic wars became the target of a group of caricaturists who appeared in Charles Philipon's publication *La Caricature* in the 1830s. For instance, Henri Monnier, poking fun at the newly rich in France, drew a very fat and prosperous figure which he titled "Victim of the Old Regime."

The most famous of the artists who appeared in *La Caricature* was Honore Daumier, who did ninety political drawings, one of which, a cartoon of King Louis Philippe, led to a jail term of six months. He was especially biting in his depictions of the justice system. In one of his cartoons he shows a man in court gagged, his arms pinned back by three men, while the smiling judge says: "You have the floor. Explain yourself."

In the United States after the Civil War, Thomas Nast drew cartoons for *Harper's Weekly*. One of his targets was the corrupt Boss Tweed of New York City, whom he drew as a fat figure with a bag of money for his head.

The twentieth century brought an avalanche of political drawings, especially in the radical publication *The Masses*. One of the most famous artists in this era was Art Young. The years just before World War I were times of intense labor struggles–in Lawrence, Massachusetts, in Paterson, New Jersey, in Ludlow, Colorado. Art Young drew an enormous military figure plunging his rifle into the body of a striker, while the rich employer nearby is saying: "Very unfortunate situation, but whatever you do, don't use force." The First World War provoked Robert Minor, also in *The Masses* (a publication that was soon to be suppressed), to draw a huge muscular figure, without a head, as an army medical examiner says: "At last, a perfect soldier."

That use of political cartoons to lampoon the rich, the war-makers, the racists of American society has continued down to the present day. Robbie Conal's extraordinary caricatures are in this tradition. His art is outrageous, bold, unsparing, and constitutes a welcome offering to the struggles of Americans against war and injustice. This collection of his art is therefore to be celebrated by all who see the marriage of art and politics as playing a vital role in the movement toward a just society.

–HOWARD ZINN

Howard Zinn is the author of A People's History of the United States.

ROBBIE CONAL: ARTIST PROVOCATEUR

DURING A ONE-NIGHT SNIPING SPREE IN 1986,

as Congress investigated the first Teflon President's most notorious constitutional transgression, known as "Irangate," the illicit arms deal with Iran to financially support Nicaraguan anti-Communist rebels, hundreds of small posters with the headline "Men With No Lips" were illegally wheat-pasted around New York City. Pictures of President Ronald Reagan and three of his resolutely tight-lipped cabinet secretaries were stuck on construction boardings and tenement walls. These cheaply printed missives were the first and for some time afterward the only graphic protests against a scandal that underscored Mr. Reagan's immunity from public criticism. In subsequent months and years, many more posters painted in the same expressionist-representational style turned up in New York, Washington, and Los Angeles, attacking Clarence Thomas's Supreme Court nomination, Senator Jesse Helms's war against art, and George Bush Sr.'s first Persian Gulf invasion. Indeed, the whole world (well, at least me and a couple of friends) started wondering from where these jibes at power emanated.

Following a massive investigation (actually, two lucky phone calls), I learned that the posters were the result of a series of personally funded, strategically executed so-called "art attacks" by a former New York "red-diaper baby" turned painter living in Venice, California, who went by the *nom de plume* Robbie Conal (that coincidentally happened to be his real name). The art attacks had been posted by Mr. Conal's personal band of volunteer snipers (illegal poster hangers). Whenever the muse struck (on the average of three or four times annually), Mr. Conal called into action his pre-dawn assault teams, who stealthily maneuvered their way through various cities adhering messages while risking fine or arrest. During the eighties and nineties when government misdeeds were constant and public outrage was mute, Mr. Conal's actions were necessary and his continued efforts were welcome.

So after September 11, 2001, when the nation was reeling from terrorist attacks on Washington and New York, Mr. Conal was one of a few graphic commentators who did not give our elected and appointed leaders (notably George Bush II) a free ride. Within months of the tragedy, Mr. Conal began a frontal art attack on the ominous-sounding Homeland Security with a poster called "Tower of Babble" that questioned the Bush/Ashcroft policies of civil liberties abridgement, and questioned the ultimate effectiveness of the proposed (and ultimately legislated) new bureaucracy of protection. Posting such critical missives may have been considered intemperate at a time of national crisis, but Mr. Conal (whom I will from here on call Conal) was not about to be stifled when he recognized that freedom demanded as many dissenting voices as possible. Now that the antiwar movement has started revving its motors,

Conal is speeding along at an even faster clip, and with his ARTBURN pages in the *LA Weekly* he has expanded his satirical critique into broader realms of popular culture.

Conal's initial decision to become an artist-provocateur was "a plot to escape from the friendly confines of the art establishment," he says, "which I joined as a painter after majoring in psychedelic drugs in college during the late 1960s." He calls his art "infotainment," because being deadly serious is not what a non-sanctioned public artist should be. "I know that people on the street will ignore a humorless message on their way to work in the morning, and besides, I have a sardonic twist to my sensibility,"

Guerrilla street sniping is the most direct unmediated form of public expression available to pictorial artists. "It's also narcotic," Conal insists, "and illegal. But if you're a pissed-off painter with a gripe against your government's abrogation of civil rights in the name of 'Homeland Security' (and color-coded national alerts, whatever they are), and you want to reach the Public with a capital 'P,' there's nothing like a little late-night urban art attack to get your freak on." Conal defines this form of minor civil disobedience as misdemeanors perpetrated to protest higher crimes.

Conal is the quintessential trickster whose role in society is to subvert complacency and inject unspoken truths. He takes sides, but only in the struggle of reason against absurdity. For example, during the farcical 2000 presidential election, he produced an election-year diptych of what he called the evil twins, Al Gore and George W. Bush, that read: "TASTES LIKE CHICKEN!" (Al Gore) and "THE OTHER WHITE MEAT!" (George W. Bush). Conal once told me in a sarcastic yet honest manner that making these statements is his way of "expressing myself in public about issues that drive me crazy." For six years, the *LA Weekly* has given him (legal) sinecure for his expressions of frustration caused by "the abuses of power by politicians and bureaucrats in the name of representative democracy." But even this vent to blow off steam hasn't quenched his apparently insatiable thirst for rants and raves: "They're so hypocritical–fucking with democracy and the Constitution," Conal says with nasal tones about the powerful and power-hungry.

Of course, Conal realizes that regardless of what he says, paints, or posts, it is hubris for an artist to try to change people's minds about issues that are important to them. But guerrilla poster-making appeals to a healthy number of people, "and colloquial American English happens to be the most subversive form of communication on the planet," he says. "So I just rubbed them together to see if I could make a spark and get myself off." Sage words from a guy whose work annoys his targets while amusing (and inspiring) the rest of us.

—STEVEN HELLER

Steven Heller is the author of over 80 books on graphic design, political art, and popular culture.

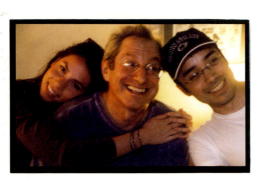

Bambi, Robbie, and Mr. Bill working hard (hardly working).

ARTBURNED

I THINK IT WAS EARLY '97

when Sue Horton, then-editor of *LA Weekly*, asked what I thought of running a regular page by Robbie Conal. Sue dug Robbie's posters and was responsible for getting his drawing of Pat Buchanan on a *Weekly* cover during the '96 presidential campaign. I think my answer was something along the lines of "Hell, yes!" And as simple as that, Robbie's cast of miscreants became part of the *Weekly*'s visual personality. He called the page "ARTBURN."

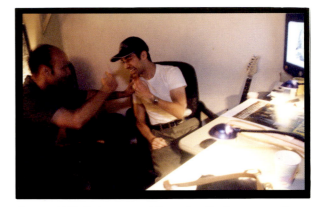

Dana and Bill discuss amongst themselves (business as usual).

Robbie's first victim that spring was none other than Bubba Clinton–whose exploits now pale in comparison to the current regime. Clinton became a favorite whipping boy over the next couple of years, appearing in ARTBURN no less than four times if you count the cover of the Democratic Convention special issue. The style of the page was true to the look of many of Robbie's posters: large central image and bold, sans-serif type knocked out of black bars. Simple, yeah, but I had no interest in messing with the formula. We weren't being lazy, the greatest elements in Robbie's posters to me were always the images, and keeping the type in boxes on the edges seemed like a good approach. In fact, when I had my way, the type would all but disappear. Looking at the early pages, it's not hard to tell which were my favorites: Henry (Mouseketeer) Kissinger, "Pet Peeves," "Caveat Empty."

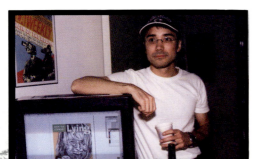

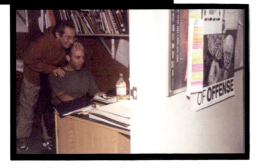

Robbie had wilder graphic visions, though, and in the second year of ARTBURNS we began to experiment. A rhythm developed that made the most of our ridiculous schedules. Right before we were to run a page, I'd get a call like, "Hey, Bill, can you find a typeface that looks like balloons?" or, "I've got this font made of bones . . ." I'd cringe, pull up Adobe Type Manager, and we were off. We'd exchange e-mails and phone calls til the night of production. That evening, after the nine-to-fivers were safely out of the building, Robbie, like a guerrilla Santa, would arrive bearing Zip disks, snacks, and posters. Instantly there'd be a buzz in my small department. Tulsa, Laura, Dave–all artists–happily stopped whatever they were doing to

Above: Punxsutawney Bill at the helm.
Below: The Braintrust–Robbie tries to find Dana's brain.

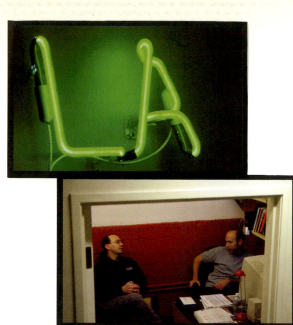

Above: The only real light in the Bat Cave.

Below: Dave and Dana make room for their invisible friend (one of Dave's "other personalities").

chew the fat with Robbie. Often accompanied by an entourage of art students with monikers like H-Bomb and Bambi (the students would sometimes help create the designs), they'd take over the *Weekly*, or at least my office. Fueled by coffee, wine, donuts, and ice cream, we'd spend the next several hours making a page that would hit the street in days. It was always the balancing act of "How elaborate do we want to be?" vs. "How late do we want to be here?"

Our solutions—often a result of poring over page after page of old Dover type books —could be tasteless and a bit literal. But I always set out in earnest to follow Robbie's concept and quite often what we got was something cheesy, yes, but also appropriate and entertaining. Think about the needle-point typography with Hillary Clinton or the firewood font with John Rocker that spelled out "Eat More Possum" (that one still cracks me up) or the Eisner vs. Katzenberg wrestling-poster parody.

Each year the pages seemed to get a little more ambitious. We'd figured out ways of squeezing more time and resources from the system. Always the ringleader, Robbie could coordinate researchers, photographers, art directors, designers, students, sign-painters, and, on occasion, trained bears, to produce his pages and posters. This collaborative circus led to some of my all-time favorite ARTBURNS: "Tastes Like Chicken," "Enronergizer Bunny," "Tower of Babble" . . . What's around the corner for Robbie's pages in the paper, I don't know. Like all good pulp, it'll most surely involve bad men, guns, and money. Whatever's in store, I'm look forward to being a small part of it.

—BILL SMITH

Bill Smith was Art Director of the LA Weekly *from 1995-2003.*

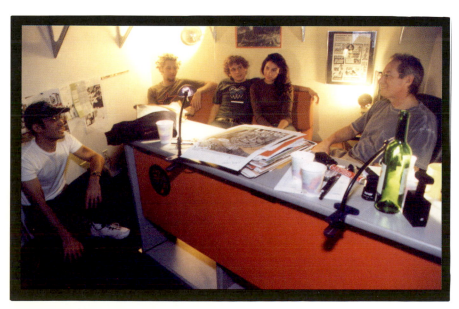

Robbie's Bunnies take over the Bat Cave: Chuckles, H-Bomb, and Bambi.

ANOTHER FINE MESS

I LOVE GUERRILLA POSTERING

–actually, I'm addicted–but getting it all together is a magilla (a big song and dance number). And I only get up around four times a year. Not that I'm complaining, just getting old. Unfortunately, there are way too many bad guys and much too little time. In 1997 I got lucky. Sue Horton, then-editor of the *LA Weekly*, Los Angeles' premiere free paper, made me an offer I couldn't refuse: Do a page, same format as the posters (though smaller), with about 50 words of secondary text (explain yourself!), once a month. More shots at the big shots–equal-opportunity satire and a chance to get to more subjects: talk-radio pundits (Rush Limbaugh!), schlock-culture mongers (Disney Studios–"Mauschwitz" to us Angelenos), lifestyle gurus (Oh Martha!), even Major League base-ball (that John Rocker is a helluvan American). We decided to call the column "ARTBURN," a pun on the pain in my heart and my so-called profession.

" *I myself feel that our country, for whose Constitution I fought in a just war, might as well have been invaded by Martians and body snatchers. Sometimes I wish it had been. What has happened, though, is that it has been taken over by means of the sleaziest, low-comedy, Keystone Cops-style coup d'état imaginable. And those now in charge of the federal government are upper-crust C-students who know no history or geography, plus not-so-closeted white supremacists, a.k.a., Christians, and plus, most frighteningly, psychopathic personalities.* "

–Kurt Vonnegut, interviewed by Joel Bliefuss for *In These Times*, 2-10-03

I'd do an original charcoal drawing on canvas, think up some wise-ass wordplay, and write a paragraph including a factoid or two about the subject at hand. Sounds easy enough. But I'm an artist. I always tell people I'm not a political cartoonist (they do five drawings a week–that's way too much work). I do adversarial portraiture. Hah! I have to suffer over my choices; worry about what to be worried about. Like the printing: I'd only done drawing for offset litho posters. This was PULP–85 l.p.i. on crappy newsprint cranked out on a Webb press. What you're about to see are facsimilies of the actual printed pieces. With print blotches* and ads bleeding through the porous paper. Now I kinda love it (it's appropriate for my seedy subjects), but it took me a while. And of course, I'd always wait until the last minute and panic. Then my pal, Al Shaffer, my photographer since 1988, would drop every-thing to shoot a 4" x 5" transparency of the art, and I'd make a mad dash down to the production floor of the *LA Weekly* to hang with the art director, Bill Smith, and his crew. That's where the real fun would begin.

A word or two about the culture of the *LA Weekly*: It's been a late-night, rock'n'roll underground kind of joint ever since it's hip-pie-esque inception in 1978 (don't let the punk scene date fool you, it was started by entrepreneurial, though still a bit woo-woo, hippies). It is staffed by talented folk whose day jobs are night work–hipsters, musicians, actors, writers, artists, tap dancers, drag queens and kings–our people.

*Dig the crazy feather on Charlton Heston's toupee on page 46.

The production floor is a maze of wild-around-the-edges creativity. You turn a corner and you're lost in some cubby-hole dripping with clippings of hand-altered comix, artifacts from garage-band shows, motorcycle ads, signs ripped from street corners and political conventions, inside jokes, and lots of photos of dogs (?). The best of the worst of sub-pop culture. Like an anti-graduate school coed dormitory.

Bill is the most talented art director I've ever worked with (he just left for greener pastures–one day I know he's going to turn his Penn State baseball cap forward and ride off to a barn somewhere in Punxutawney, PA). His posse: Dana Collins, a Seattle speed-metal band survivor (his band was The Accused–nuff said), Dave Shulman, the best improvisational head I know, Tulsa Kinney, surfing the curl of the alternative art scene, and Laura Steele, solid rock with a pedal-steel high register not to be believed. They were usually dug in so deep (the boys were basically down in Quake 3 Arena) when I scrambled in, they'd barely notice I was alive. I was usually half dead anyway. When Bill would finally have time for me, we'd scan Al's "tranny" and start pushing around the images and text on his computer, finding appropriate fonts for the words (and lighting up John Ashcroft's eyes with glowing Terminator-red lasers). Actually, I'd just sit and kibitz, he'd do all the work–and the cackling would begin. What I call the "Heh-heh-heh Factor" in the art making process. You've got to at least think it's going to be cool, otherwise, why do it? Dana would hear us and eventually creep out of his dark hole ("Corrosion of Conformity" bootleg tapes downloading off his computer), sidle in, and suggest something salacious. We'd have a word problem: what's a synonym for "vapid," or "putrescent" isn't funny enough. Bill would yell, "Dave!" And the hep-cat in the hat would slink over mumbling four ideas at once, basically interrupting himself, or his selves. When Dave landed, the game was on. We'd be huddled around Bill's computer, trying to turn shit into shiznit. Getting louder. Kateri Butler, the Style Editor, would flutter by, her black sweater trailing like a cape, in a huff about some last-minute changes to something. She'd pick up the vibe and just shake her head, laughing at us. Tulsa would stick her head in and tell me I'd missed another hip opening somewhere in Silverlake. And, "What the hail are you boys doin' in there anyway?"

Eventually we'd need fuel–race out for Persian ice cream or take a field trip to the corner burger joint for chili-cheese fries. The later it got, the nuttier the design "solutions" and the text became. The staff would slowly skulk away, one by one–by the time we really got going, Elvis would have left that building. Often we got so bad, even Mother Sue, the Editor-in-Chief, wouldn't go for it. And she was my personal editor–I can't count how many times she saved my ass, making my text read like I could actually write English, checking a factoid so I wouldn't get, well, sued. So I've included some remixes–a visual equivalent to Moby appropriating slave and chain-gang field hollers and incorporating them into techno-trance dance favorites. Or maybe not. The remixes are versions of ARTBURN that we had great fun with and the *Weekly* would certainly never publish.

Sending up the motley crew we've collected here is not the stuff of rocket science. It isn't particularly profound. Just one way of turning anger, disappointment, sometimes utter disbelief at the unconscionable doings of our political and cultural leaders into a form of silly–satirically joyful–resistance. I hope you get a kick out of it.

–ROBBIE CONAL

Oops! . . . I Did It Again!

"Say it ain't so, Colin. Say it ain't so." That's what many people are asking the great black hope to do these days. Colin Powell was supposedly the lesser of all evils in the Bush hierarchy, even though he had been Chairman of the Joint Chiefs of Staff and ran the first Gulf War for Dubya's dad. Well, fuggedaboutit! He's Darth Vader Lite: a fucking five-star general, masquerading as the Secretary of State. If we thought he'd learned anything from two tours in Vietnam, helping cover up the My Lai massacre*, being a battalion commander in Korea, leading the 2nd Brigade, 101st Airborne, and V Corps in Europe—and blowing the hell out of Iraq once already—maybe we're unclear on the concept. Or guilty of wishful thinking. Maybe he feels bad about it, but he certainly learned how to go along to get along. He even learned that he hadn't blown up enough Iraqis the first time. This time it's 3000 precision-guided missiles in 48 hours designed to produce "shock and awe." In other words, death and destruction. Colin's Commanders have even ruined big-budget war movies for me. Those orgasmic explosions every 15 minutes just aren't enough

"War is necrophilia, that's what it is."
—Chris Hedges, *New York Times* reporter, on *NOW with Bill Moyers*, PBS, 3-7-03

anymore. Even martial arts chopsocky movies—Asian, black, and white guys and gals tumbling their destructive, traffic-jamming paths through major cities—seem prissy. Now all I watch are totally paranoid action-fantasy films like *Enemy of the State* and *Minority Report***. I'm just a clown with a piece of charcoal, but I can go Chris Hedges one better: War is people fucking other people to death. Saddam is (was?) an evil guy, but what have the people of Iraq done to us lately?

*As a major in Vietnam, assigned to review letters about the massacres, Powell was dismissive when faced with evidence of American troops' atrocities (Robert Parry & Norman Solomon, www.consortiumnews.com/archive/colin3.html).

**The only television show I watch consistently these days is *The Pet Psychic* on Animal Planet.

Oops! . . . I Did It Again
(Pictured: Colin Powell)

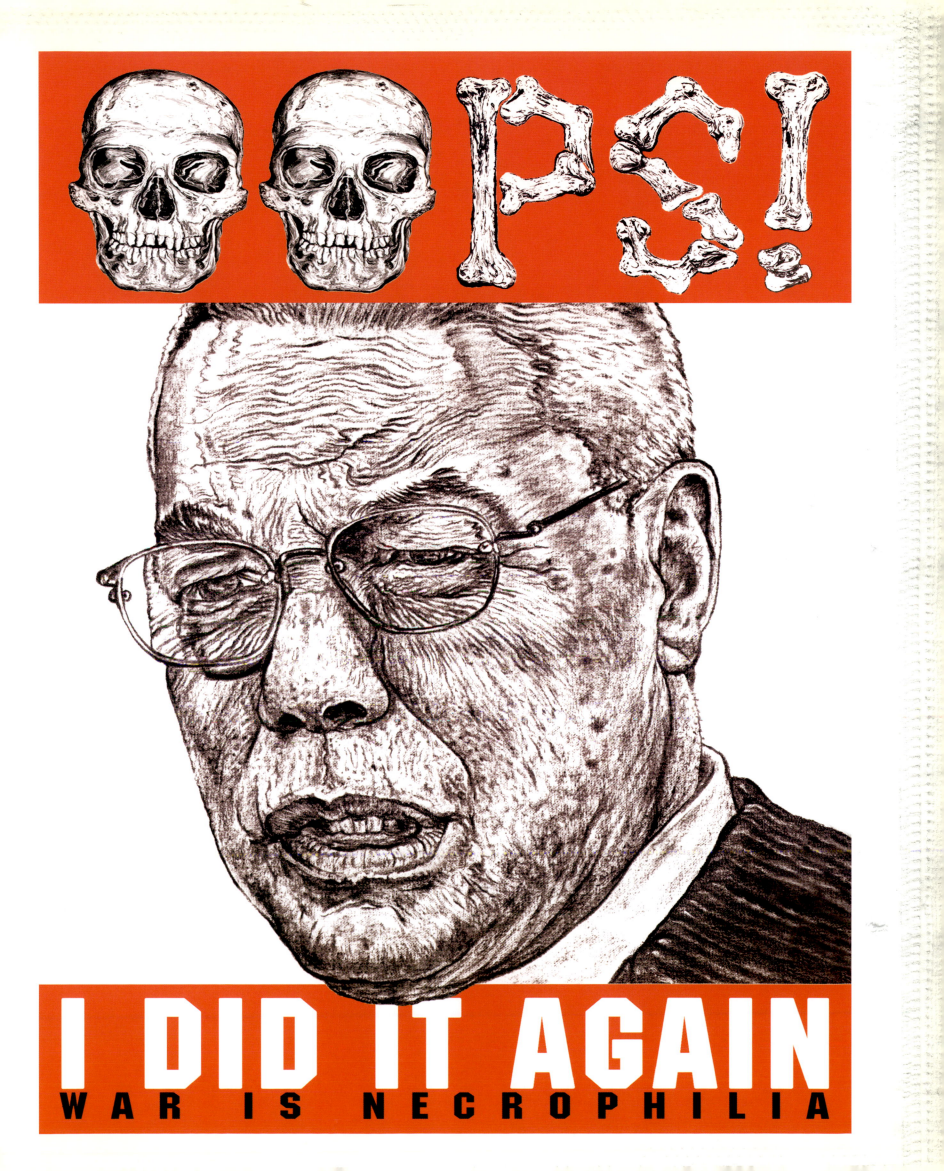

> **" Martha Stewart said Tuesday she wants to 'focus on my salad,' but paused from cabbage-slicing to predict that the investigation of her stock dealings will be resolved and 'I will be exonerated of any ridiculousness.' "**
>
> —CBS Online, *The Early Show*

Martha Stewart Lying

If a man's home is his castle, Martha Stewart's home is her Empire. With an All-American combination of will, talent, and consumerist relentlessness, she's made herself the home-design dominatrix of middle-class decoration, embodying the "getting over the Joneses" jones of the country bourgie wannabes, or to put it pretentiously, faux-nouveau riche. Is Kmart faux enough for you? Martha, herself, was born Martha Kostyra, New Jersey working-class Polish, though there's nothing faux-nouveau about her. She's worth a billion.

As a Martha fashion-slave, you can make a purr-fect dining room table flower arrangement for that big dinner party for the CEO of your company–if you just do it Martha's way (and spend $15 per flower for the 20 ecru-colored chrysanthemums she demands).

If there seems to be a contradiction here, it's just that Martha is omnipresent. Her company, Martha Stuart Living Omnimedia, is self-explanatory. But Martha is in rare air, so cut off from the real world that her little village of insiders–inside the Hamptons, for instance–just considers cocktail-party chatter to be business as usual. Martha's an ex-member of the Stock Exchange, herself, and should know better, but she and her country-club cronies are so insulated that they figure the laws of the United States don't really apply to parties within their estates.

Martha Stewart Lying
(Pictured: Martha Stewart)

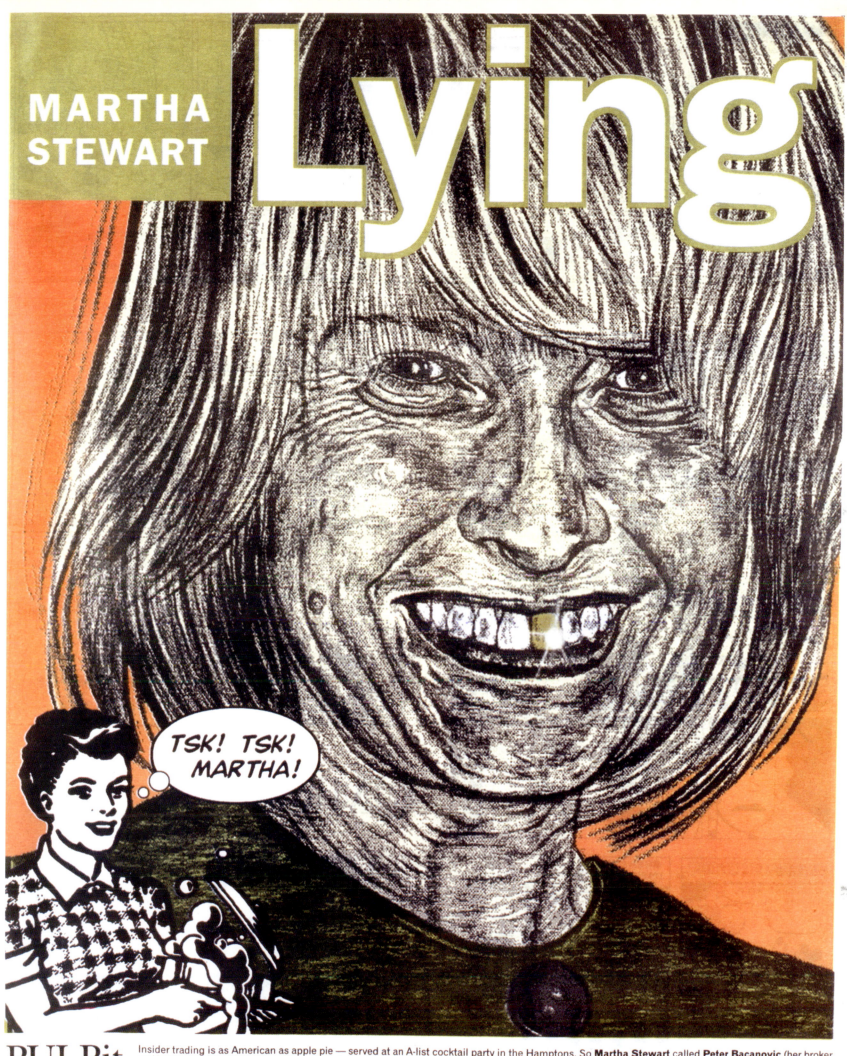

MARTHA STEWART **Lying**

TSK! TSK! MARTHA!

PULPit BY ROBBIE CONAL

Insider trading is as American as apple pie — served at an A-list cocktail party in the Hamptons. So **Martha Stewart** called **Peter Bacanovic** (her broker and best young friend) from her cell phone on her private jet to sell her 3,928 shares of ImClone a day before the FDA nixed ImClone's new cancer drug, causing the stock to plummet. So she called **Sam Waskal** (ImClone's CEO and her best old friend) to get the scoop on why the stock pooped. That doesn't mean she did anything "wrong." But then Martha lied to Congress. It's not a good thing.

[Thanks to Marc Peyser at *Newsweek*] www.robbieconal.com

> **"The best place after your visit (to the Cathedral) is the air-conditioned gift shop. It takes all kinds of [credit] cards, but has an ATM in front."***
>
> —Cardinal Roger Mahony, at inaugural dedication mass for Grace Cathedral in Los Angeles

Erectile Issues

What a Cathedral gift shop it is! You can buy Our Lady of the Angels Cathedral souvenirs and Our Lady of the Angels Cabernet Sauvignon for $10.99 per bottle. I saw a rubberized ceramic figurine of two Padres giddily joined at the hips, with a hole drilled through their touching torsos. A bottle of wine was jammed head-first into it—the thing is a wine holder, I swear (the nice lady at the cash register told me the tipsy Padres bottle holder was from the Cardinal's personal collection). The *coup de grace* is a below-the-hallowed-ground crypt for $3 million and change. Now that's what I call one-stop shopping.

And there's plenty of hallowed ground to go around—43,000 square feet of it. Although the million, uh, wealth-challenged parishioners it serves might not feel quite so welcome, dead or alive. During the inaugural, protesters from the Catholic Worker soup kitchen just down the street—situated in the "Nickel," a homeless ghetto smack in the heart of the downtown business district of LA—held up a big banner, "Spend God's Money on God's Poor." It's true, the Raj has spent almost $200,000,000 on his "Taj Mahony." (If he ever gets around to paying the artists he commissioned to decorate the place, the costs will escalate to at least $200,000,001.) He'll make it all back in burials alone, but unless he pays for a new paint job, the joint will forever be an enormous cube of Swiss cheese. Anyway, "His Holiness" takes on a whole new meaning when you think of the stink of those pedophile priests he's been hiding under his robes for the last decade or so. No wonder he looks a little light on his feet. We call him "Rajah the Dodger."

*Compliments of the Parishioners Federal Credit Union. It's literally built into the exterior wall of the gift shop, next to the front door.

Erectile Issues
(Pictured: Cardinal Roger Mahony)

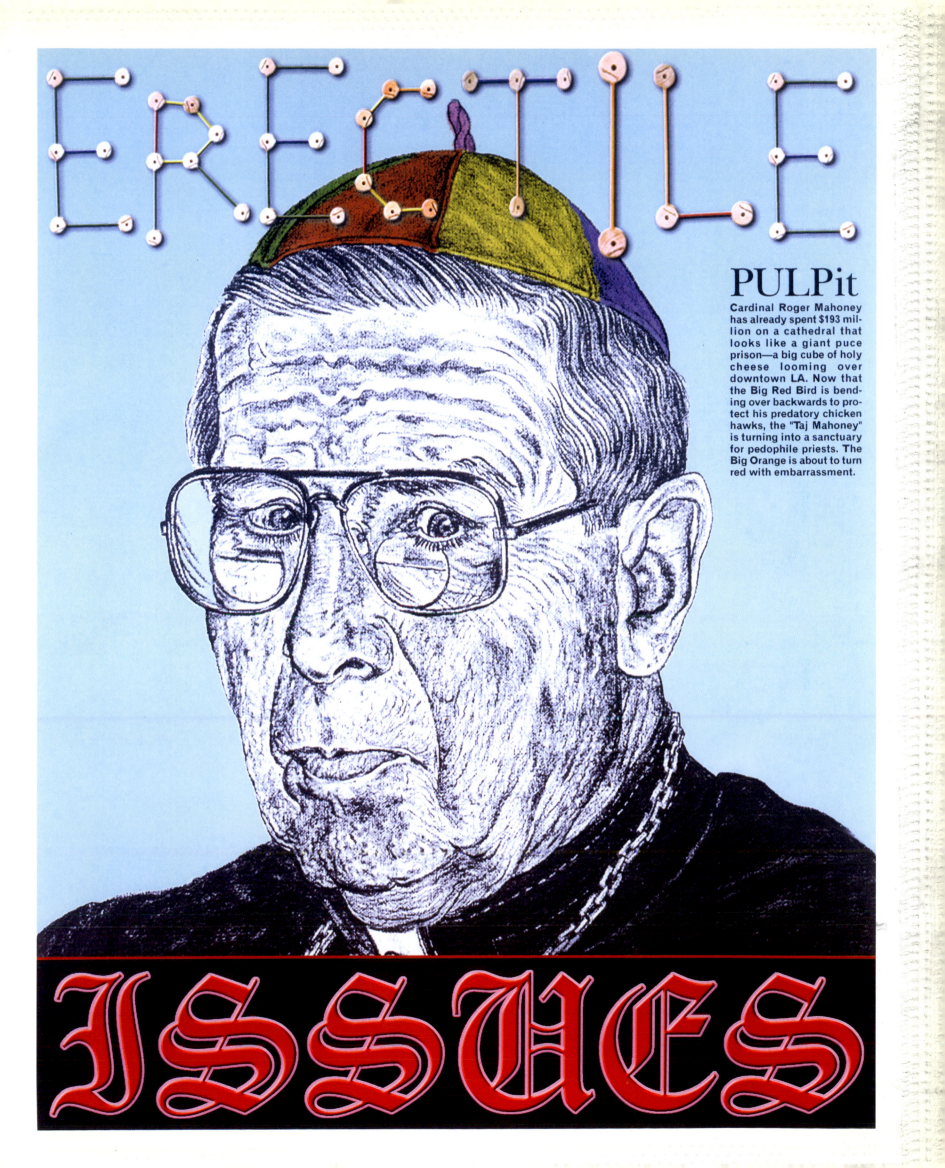

ERECTILE

PULPit

Cardinal Roger Mahoney has already spent $193 million on a cathedral that looks like a giant puce prison—a big cube of holy cheese looming over downtown LA. Now that the Big Red Bird is bending over backwards to protect his predatory chicken hawks, the "Taj Mahoney" is turning into a sanctuary for pedophile priests. The Big Orange is about to turn red with embarrassment.

ISSUES

Enronergizer Bunny

Most of us probably think it's the other way around, but Dick Cheney is Donald Rumsfeld's protégé.* Back in the good old bad old days of the Nixon administration, Rummy brought Little Dickie into the Office of Economic Opportunity (how perfect is that?) as his special assistant. In '74, when Rummy was President Ford's Secretary of Defense, he made sure Little Dickie came into the White House as Chief of Staff. Of course, during the last Gulf War, Big Dick (all grown up) was senior Bush's Secretary of Defense. And now it's Rummy's turn. Chummy, ain't it?

Dick has certainly made the most of his economic opportunities: running Halliburton into, or under, the ground (overstating profits by $445,000,000), while making himself rich; hanging out with Ken Lay and the cowboys at Enron, while hiding everything he can from the American public; stonewalling the General Accounting Office on meetings held by his

> ## While the collapse of Enron is giving the nation a dramatic lesson in the importance of conscientious public disclosure, Cheney is still manning the barricades, pinstripes waving, defending the Bush team's dearly held principle: 'Damn the public—secrecy first!'
>
> —Scott Rosenberg, Salon.com, 1-29-02

energy task force to conceal the Administration's links with the bankrupt (rhymes with "corrupt") crooked E; not to mention the influence that energy companies have over U.S. energy policy**. *Duh!*

*For a recycled bunny with Rummy, see page 76.

**Time, 2-3-02, "Getting the Ear of Dick Cheney" by Michael Weisskopf and Adam Zagorin

Enronergizer Bunny

(Pictured: Dick Cheney)

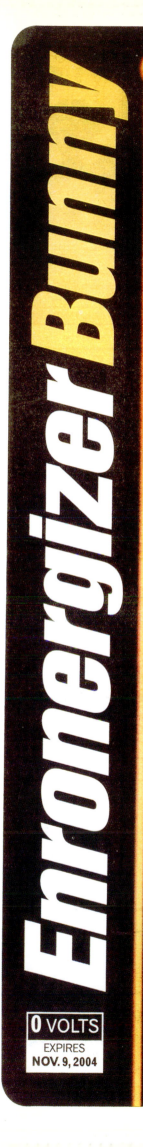

Enronergizer **Bunny**

0 VOLTS
EXPIRES
NOV. 9, 2004

DICK Cheney is a high-energy guy.

➤ He was CEO of Halliburton, a giant Texas construction and engineering company that services Texas oil companies.

➤ DICK is battery powered — his pacemaker keeps all that bullshit, er, big oil pumping through his veins.

➤ He wrote a national energy report but didn't mention "Crooked E" CEO Ken Lay's many visits to the White House, including Kenny Boy's participation in the White House Easter Egg roll.

➤ What other energetic White House games did DICK and Kenny play?

➤ Is Kenny Boy's pet name for DICK "Bunny"?

> **"The pagans and the abortionists, and the feminists, and the gays and the lesbians… the ACLU, People for the American Way, all of them who have tried to secularize America: I point the finger in their face and say, 'You helped this happen.'"**
>
> —Jerry Falwell on 9-11, interviewed by Pat Robertson on his TV show, *The 700 Club,* 9-13-01

Eyes Wide Shut

Personally, I'd point a different finger the other way. Jerry Falwell and Pat Robertson's sanctimonious pin-headed view of the world beyond their fundamentalist Christian tele-pulpits might just have something to do with the answer to my favorite All-American post-9-11 question: "Why do they hate us?"

They were raised in the big chill of the Commie-hating, black-and-white (black versus white?), Bible-thumping 1950s–and as far as I can see, that's where they've gone: back to the future. Where J. Edgar has our backs (don't bend over, boys). And so many politicians', business leaders', and cultural icons' balls in his pockets, he needs a walk-in closet for his extra suits (and that leopard-skin pillbox hat, accessories, and a little black dress or two).

Pat'n'Jerry are praying for the G-man to bail us out of the pickle barrel we've made of our relationship with the rest of humanity. J. Edgar *was* the pickle!

These guys think America is God's country. *Their* God's. The God who likes women barefoot and pregnant and in the kitchen. If you don't believe me, dig this quote from Pat Robertson:

Feminism is a socialist, anti-family, political movement that encourages women to leave their husbands, kill their children, practice witchcraft, destroy capitalism, and become lesbians. *

These guys have more in common with the Taliban than they think. Well, they *don't* think. That proves it!

*Fund-Raising letter from 1992, *The Washington Post*, 8-23-93.

Eyes Wide Shut
(Pictured: J. Edgar Hoover, Jerry Falwell, and Pat Robertson)

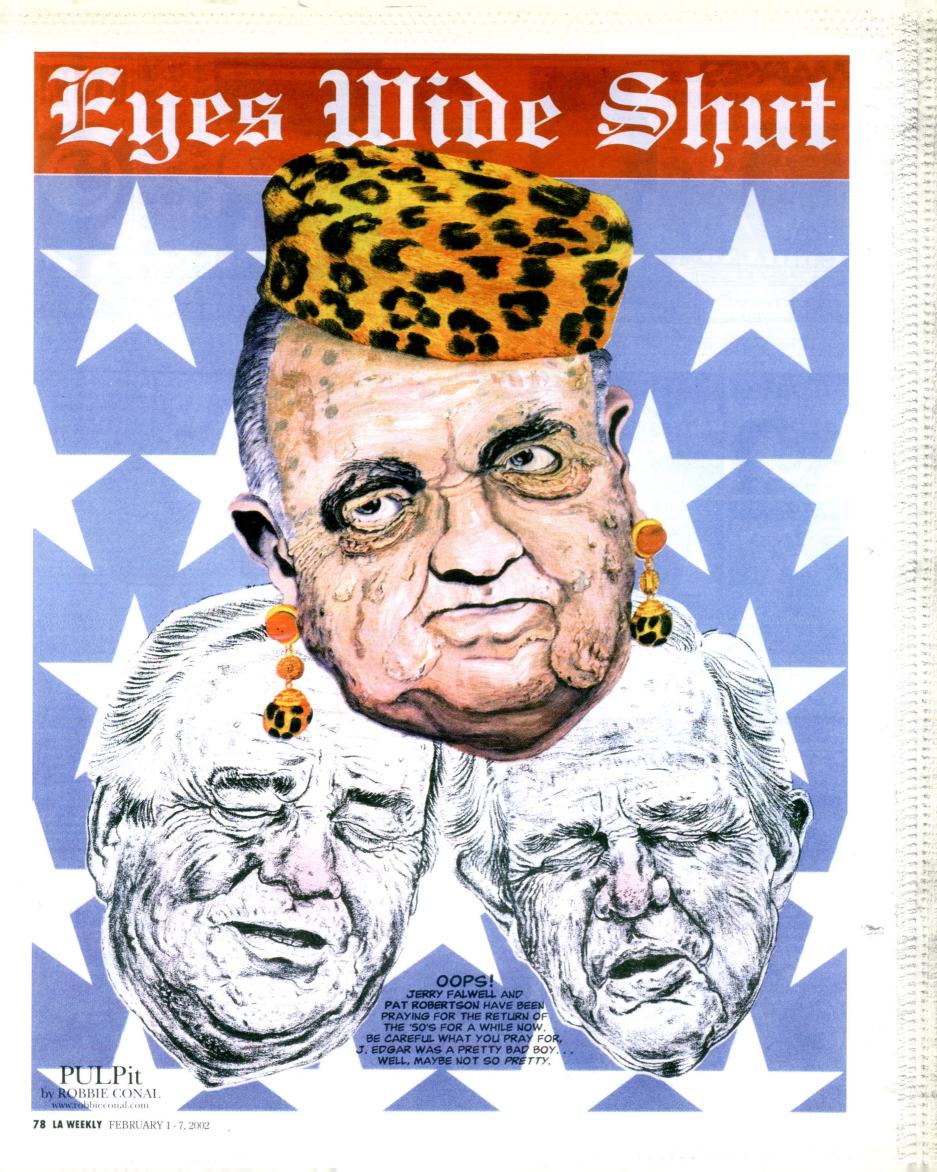

Eyes Wide Shut

OOPS!
JERRY FALWELL AND
PAT ROBERTSON HAVE BEEN
PRAYING FOR THE RETURN OF
THE '50'S FOR A WHILE NOW.
BE CAREFUL WHAT YOU PRAY FOR,
J. EDGAR WAS A PRETTY BAD BOY...
WELL, MAYBE NOT SO *PRETTY.*

PULPit
by ROBBIE CONAL
www.robbieconal.com

> **"John Ashcroft is a man who lost to a dead man in Missouri…The people of Missouri went, 'I'm sorry, John, but the dead man scares me less than you do.'"**
>
> —Robin Williams, *Live on Broadway, 2002*

Homeland!

And now we know why. Our Attorney General's response to 9-11 has been so overwhelmingly over-reactive that it seems he's plotting to control us through scare tactics–dire warnings about imminent terrorist attacks, without specifics–while substituting surveillance for civil liberties.

Maybe this was all a *Saturday Night Live* skit: a stiff clone of J. Edgar Hoover (Tom Ridge is one chromosome short of looking just like him) getting up before national TV cameras, telling us the color-coded national alert system (system?) has just gone from yellow to amber. What are we, a kindergarten class?

Meanwhile, back at the ranch, Dubya is telling everyone to "just go shopping." Dubya is busy himself, channeling the 1950s. "Axis of Evil" sounds just like a Red-scare fifties comic book title, which is probably what he's been studying up on.

This piece was a practice run for a street poster, a first draft banged out on a deadline for the *Weekly*. Bill Smith, my wife Debbie Ross, and I convened one night in Bill's office to muscle up the images and text. Billions of dollars for "Homeland Security"–a propaganda blizzard of mixed messages from the executive branch of our government (and the conglomorate media buying into this completely*)–added up to a "Tower of Babble."** I usually just make a portrait of one ugly old

> **"John Ashcroft–just the fact that he doesn't dance…there's something wrong there."**
>
> —David Arquette

man in a suit and tie, add two or three words, and leave it at that. For this poster, we threw in the kitchen sink. Which is what they were throwing at us. We put the poster up in cities around the country, starting in LA on April 1, 2002. Fools that we are.

*As Bill Moyers put it, "The exercise of free speech depends on who owns the microphone." *Now With Bill Moyers*, PBS, 2-21-03

**See page 76.

Tower of Babble
(Pictured: John Ashcroft, Tom Ridge, Dubya)

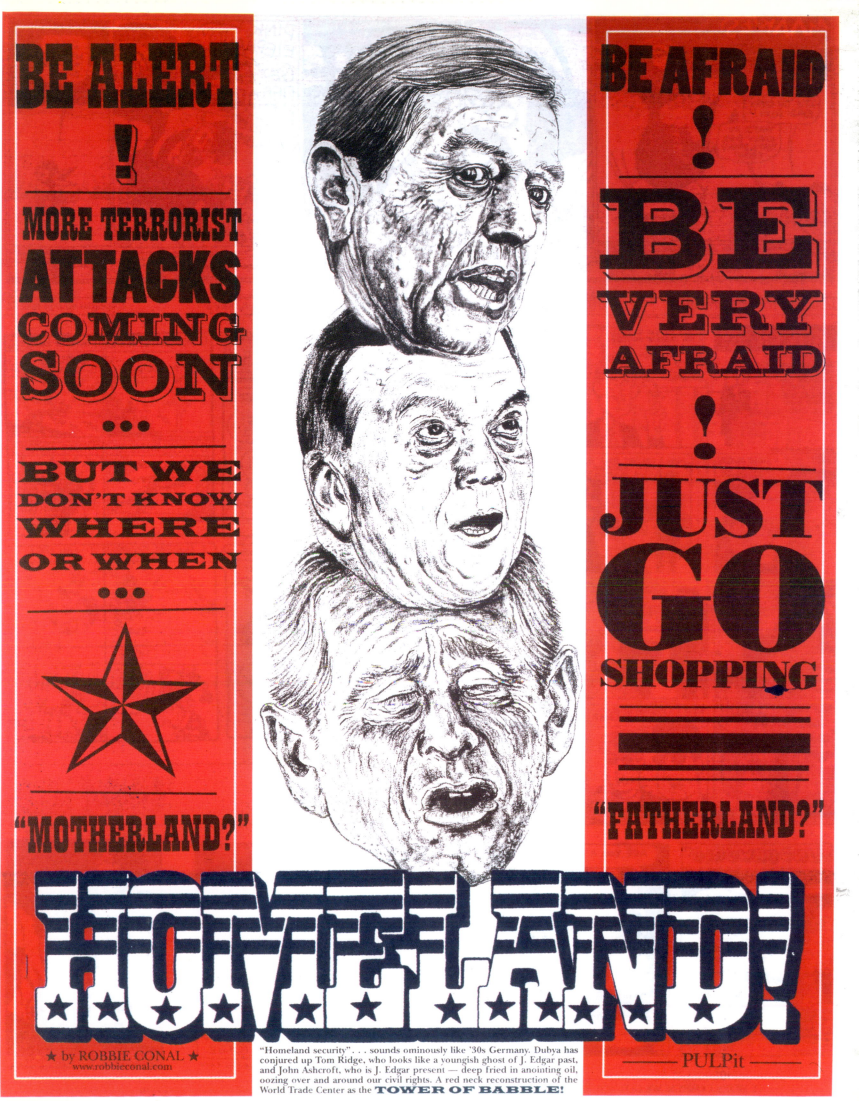

BE ALERT
!
MORE TERRORIST
ATTACKS
COMING
SOON
...
BUT WE
DON'T KNOW
WHERE
OR WHEN
...

"MOTHERLAND?"

BE AFRAID
!
BE
VERY
AFRAID
!
JUST
GO
SHOPPING

"FATHERLAND?"

HOMELAND!

★ by ROBBIE CONAL ★
www.robbieconal.com

"Homeland security" . . . sounds ominously like '30s Germany. Dubya has conjured up Tom Ridge, who looks like a youngish ghost of J. Edgar past, and John Ashcroft, who is J. Edgar present — deep fried in anointing oil, oozing over and around our civil rights. A red neck reconstruction of the World Trade Center as the **TOWER OF BABBLE!**

— PULPit —

"We're a little surprised at all the protests and we feel that the coverage has been one-sided . . . LA has a history of having projects built which pay no regard to the natural environment so [the Gehry project] could be viewed as positive."

—Jim Glymph, partner in Frank O. Gehry and Associates, as quoted in *The Guardian*, 8-18-01

Fucking Frogs

This is an environmental piece, about wetlands in Los Angeles. Commercial developers are adding 13,000 residential units and 6 million square feet of commercial space subsidized by our tax dollars. Ninety-five percent of California's wetlands have already been destroyed by commercial development. But the issue is global. Think Brazilian rain forest. Or the bald spot on top of the planet, the hole in the ozone layer.

Meanwhile, back in LaLaland, the Southern California Gas Company stores seven billion cubic feet of explosive methane gas under what's euphemistically named "Playa Vista": Beach View to us. You can see the beach because the estuary, home to froggies, herons, egrets, and fish, has been wiped out. Playa Vista workers "trimmed" the trees that were Great Blue herons' nesting places. They destroyed *all* the nests. The ghosts of unborn Great Blue herons will haunt the financiers

Goldman Sachs, Morgan Stanley Dean Whitter, and Frank Maguire III, forever.

Frank O. Gehry, himself, was planning on moving his office down to Playa Vista–he designed a few of the office buildings. Frank said, "Beverly Hills has a higher reading of toxic gas than Playa Vista."* That's a different form of toxic gas, Frank.

Playa Vista is a paradigm example of commercialism at its worst. So much so that there's even a rumor going around Hollywood that Krusty the Clown is planning to move to Playa Vista. He's trying to hire Gehry to design a new "Krustyland" to be located on a raft in the middle of the Ballona Wetlands.

We made a poster out of this piece and plastered it all over the west side of LA. A little "urban beautification" project. Any town would look better with psychedelic fucking frogs on every street corner, don't you think?

*Bob Pool, *LA Times*, 9-6-01.

Give the Fucking Frogs
Some Fucking Space

(Pictured: frogs)

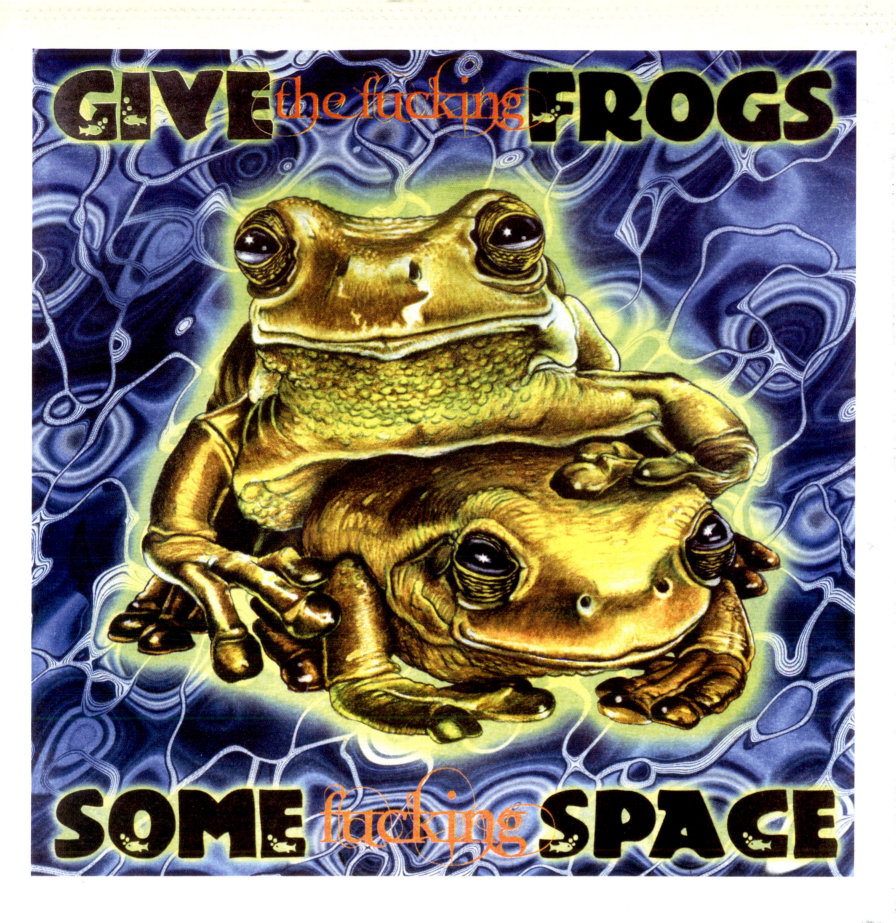

GIVE *the fucking* **FROGS**

SOME *fucking* **SPACE**

THE PLAYA VISTA PROJECT HAS LANDED - RIGHT ON TOP OF THE BALLONA WETLANDS.
THAT'S A LOT OF SQUASHED FROGS, BABY.
EXPLOITING AND DESTROYING NATURAL SPLENDOR IS A TOXIC COMBINATION -
THE M.O. OF CRASS COMMERCIALISM AT ITS WORST. IT COULD BE TURNED UPSIDE
DOWN BY DEVELOPING BALLONA WETLANDS AS A WILDLIFE THEME PARK.
MAKE IT INTO A TOURIST ATTRACTION, CELEBRATE IT, CHARGE BIG BUCKS TO
VISIT IT, WHATEVER. DO FROG TOURS, HERON FLIGHTS, EGRET WALKS.
CALL IT "WET DREAMS" FOR ALL I CARE. JUST LET IT LIVE.
AND LET ME GET TO THE AIRPORT FROM MAR VISTA IN 15 MINUTES.

BY ROBBIE CONAL | www.robbieconal.com

PULPit

Hound Dog

That's his problem.

One of the guilty pleasures of doing these ARTBURN pages is that I got to get down and dirty with sanctimonious sleazebags like Gary Condit. I couldn't afford to waste a poster on the pretty boy, but with the help of my photo-shopping hair stylist, Dave Shulman, Bill "Thought Bubbles" Smith, and a crack(ed) team of late-night comix maniacs, I managed to giddily lower myself to his level.

Condit is "Bubba Lite," except for that murder thing.*

His dad was a preacher in small-town Oklahoma. The family moved to Tulsa, where Condit met his wife, a member of the high school pep squad. Then they all moved to small-town California; his dad was pastor of the Village Chapel Free Will Baptist Church in Ceres, California. That's small. But Gary went to college. In 1972 he became a member of the Ceres City Council. Then Mayor. He was getting bigger. By '75, he and his wife had two kids. At 35, he was elected to the California Assembly. And bigger: In 1989 he was Congressman Condit, a very conservative Democrat, hanging with Newt Gingrich, a valued partner to Dubya in his so-called "plan to build bi-partisan-ship."** The dude was "Wonder Bread," wrapped in red, white, blue, and ... yellow.

Until Chandra Levy disappeared. It seems that Condit knew her. In a Biblical way. He denied it and posted $10,000 in reward money, calling her "a good friend." Then, two months after Levy's disappearance, a flight attendant revealed she'd had an 11-month fling with the son of the preacher man. Condit had asked her to sign an affidavit denying it. Sound familiar?

Whatever the deal is with Levy's death, Condit just couldn't bring himself to tell the truth. A few days later, Levy's aunt said that Chandra had told her she was having an affair with Condit. So he finally admitted it to the police, but not to the public. It gets worse, but we get the idea: This guy spent most of his life close to God (at least by way of his dad), look-ing good, thinking he was untouchable while touching everything he could get his paws on. He was a star. Not exactly the Star of Bethlehem. More like he thought he was Elvis–without the King's common decency.

*I don't think Condit had anything to do with Chandra Levy's death, but he was a total sleaze about their relationship, and it was all bad news from there.

**All quotes are from the same CNN Online article. Thanks to CNN Online for all the neat info in this piece (www.cnn.com/CNN/Programs/people/shows/condit/profile.html).

Hound Dog
(Pictured: Gary Condit)

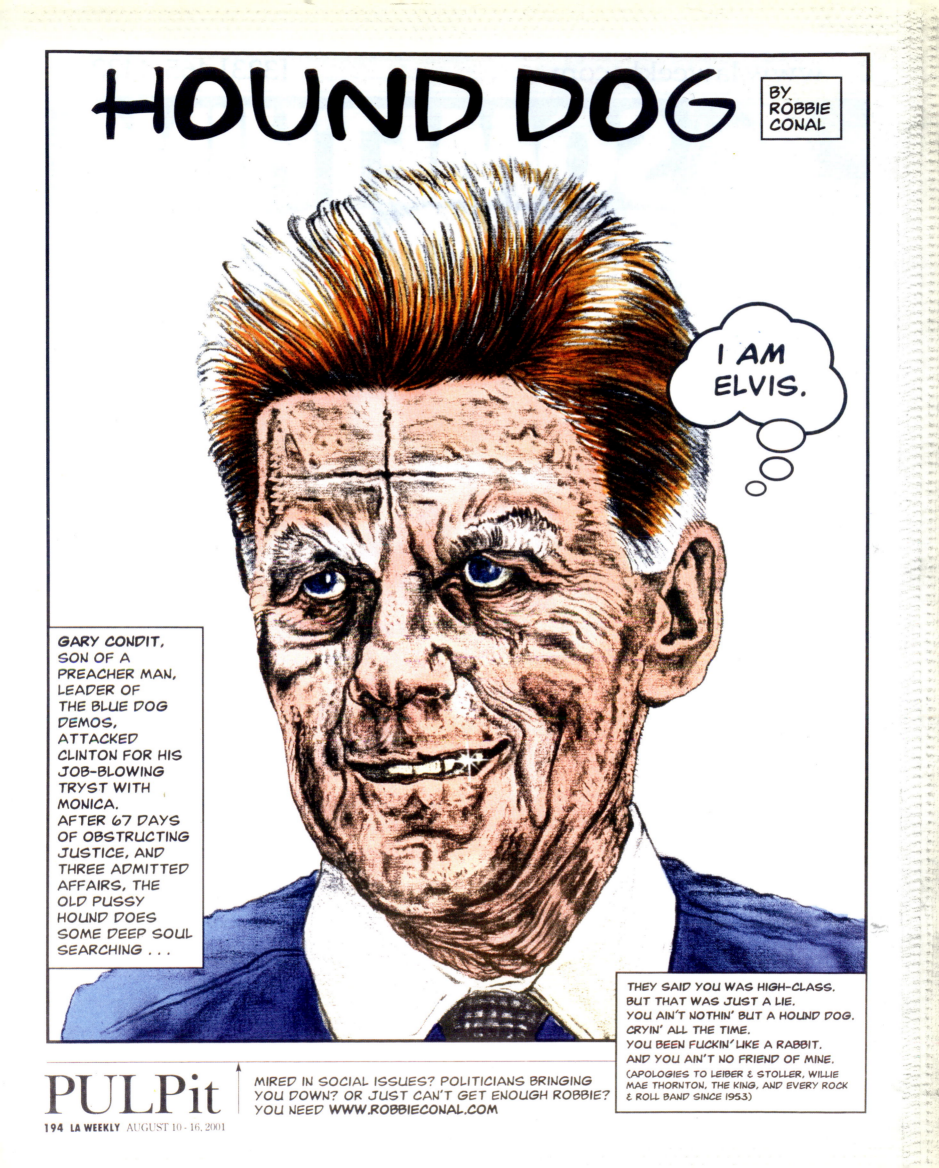

HOUND DOG

BY ROBBIE CONAL

I AM ELVIS.

GARY CONDIT, SON OF A PREACHER MAN, LEADER OF THE BLUE DOG DEMOS, ATTACKED CLINTON FOR HIS JOB-BLOWING TRYST WITH MONICA. AFTER 67 DAYS OF OBSTRUCTING JUSTICE, AND THREE ADMITTED AFFAIRS, THE OLD PUSSY HOUND DOES SOME DEEP SOUL SEARCHING . . .

THEY SAID YOU WAS HIGH-CLASS.
BUT THAT WAS JUST A LIE.
YOU AIN'T NOTHIN' BUT A HOUND DOG.
CRYIN' ALL THE TIME.
YOU BEEN FUCKIN' LIKE A RABBIT.
AND YOU AIN'T NO FRIEND OF MINE.
(APOLOGIES TO LEIBER & STOLLER, WILLIE MAE THORNTON, THE KING, AND EVERY ROCK & ROLL BAND SINCE 1953)

PULPit

MIRED IN SOCIAL ISSUES? POLITICIANS BRINGING YOU DOWN? OR JUST CAN'T GET ENOUGH ROBBIE? YOU NEED WWW.ROBBIECONAL.COM

> **" The administration's refusal to accept that drilling in the [Alaskan] refuge is a bad idea says something about its commitment to basing environmental decisions on sound science. That is, if it 'sounds' good to industry, forget about the environment. "**
>
> —Chuck Clusen, Natural Resources Defense Council's director of Alaska projects

Fossil Fool

This is about Dubya's lust for oil. I can just hear his ersatz Texas drool, er, drawl crooning, "I'm just a fool for fossil fuel." All his cowboy cronies–Enron, Halliburton, and the Texas oil industry–know that tune. Dig Jerry Jordan, chairman of the Independent Petroleum Association of America, rhapsodizing somewhat reflexively about the Bush administration: "I personally think it's great for America, but I realize that some people think there's going to be some preference for the industry. Because everybody knows they understand the industry and know they've been in the industry. My only concern honestly is that they will bend over backwards to keep from appearing helpful to the industry."*

They're bending over all right. The other way. And spreading for a drilling–just like the Arctic Wildlife Preserve in the Alaskan wilderness.

Bush's family has been "environmental"

for generations. If you define it as globalization and you include business. If you don't get all politically-correct-nit-picky about that, you can include doing business with the enemy. Dubya's grandpa Prescott managed several businesses that provided raw materials and credit to the Third Reich. They were subsequently seized by the U.S. government during WWII under the Trading with the Enemy Act. It's a family tradition: Salem Bin Laden–yes, one of Osama Bin Laden's brothers–invested in Dubya's former oil business in Texas. James Bath was one of Dubya's earliest financial backers. They were in the Texas Air National Guard together. In 1976, Salem Bin Laden made Bath his business representative in Houston . . . uh-oh.** You know the drill. This isn't conspiracy-theory shtick–OK, maybe it is a little shticky–but, unfortunately, it's more like business as usual.

*Jim Puzzanghea, "Bush Oil Links Worry Watchdogs," *San Jose Mercury News,* 2-26-01.

**There's lots more where this came from: Rick Wiles, *American Freedom News,* 9-01.

Fossil Fool

(Pictured: Dubya)

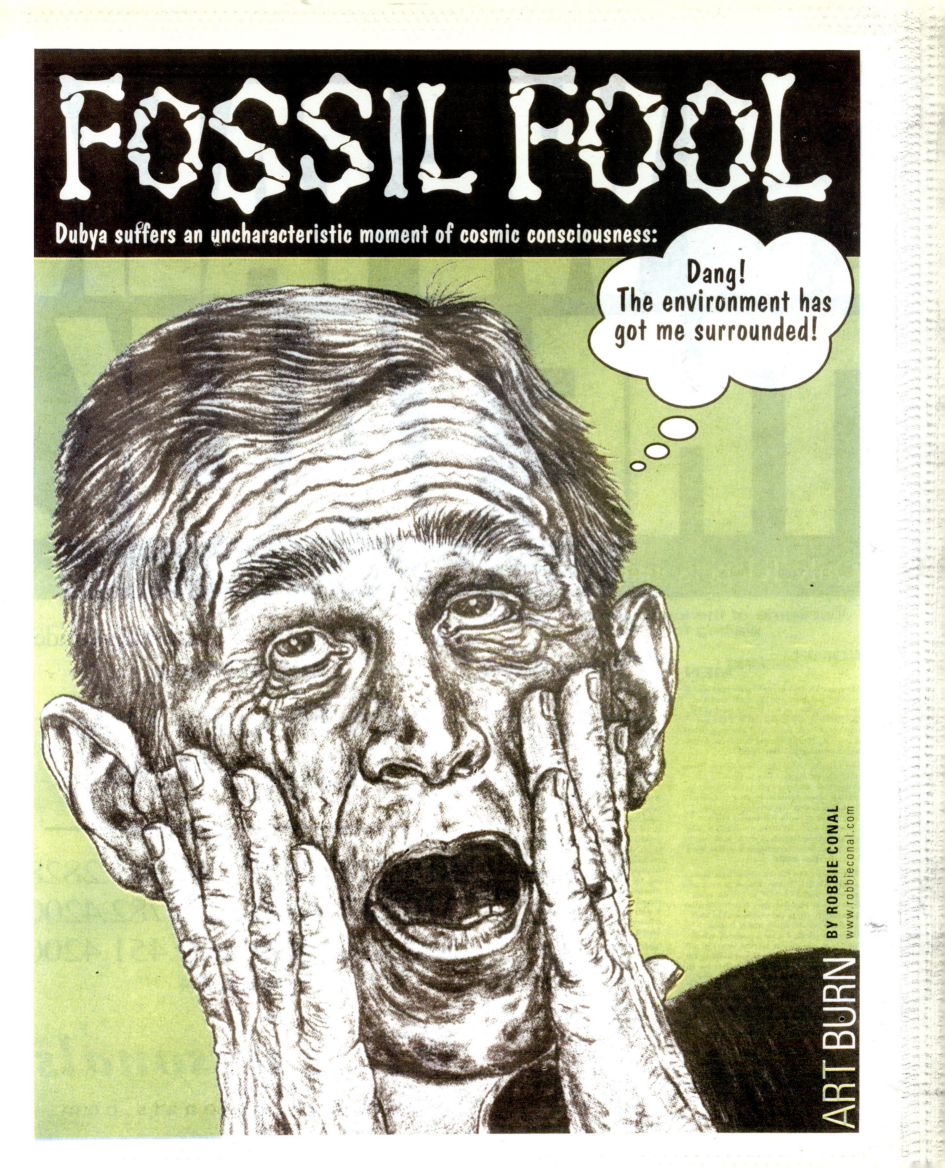

Dubya & Easter Bunny

President Bush doesn't exactly have an environmental policy. He's basically for a good BUSINESS environment. As for issues affecting the climate, like "global warming," he's for it, if it means a warm BUSINESS climate–well it does, doesn't it?

That's why the burning Bush announced the U.S. would withdraw from the Kyoto Protocol, an international agreement to control the effects of greenhouse gas emissions, thus reducing global warming, which is melting the planet. Even the U.S. Senate Foreign Relations Committee passed a unanimous resolution calling for him to sign on to a revised (weaker) version of the Kyoto Protocol. But he'd rather "encourage" BUSINESSES to reduce emissions voluntarily by offering them market-based incentives. This is akin to his policy encouraging corporations (like Enron) to monitor their own BUSINESS practices.

In January 2001, the Environmental Protection Agency adopted a new, stricter standard for arsenic in drinking water. In March 2001, the Bush Administration rolled back this rule–heck, it's tasteless (in both senses of the word), and it really doesn't hurt anybody that much. At least not as much as it would hurt the coal industry, which contributed millions to Bush's election campaign.

" *President Bush's message rivals Marie Antoinette . . . for callous indifference: 'Let them drink arsenic.'* "

–Dr. Brent Blackwelder, President, Friends of the Earth

Bush's rollback will double Americans' cancer risk from arsenic in our drinking water. And kill a lot of bunnies.

Dubya & Easter Bunny
(Pictured: Dubya and bunny)

Thanks to Rachel Massey.

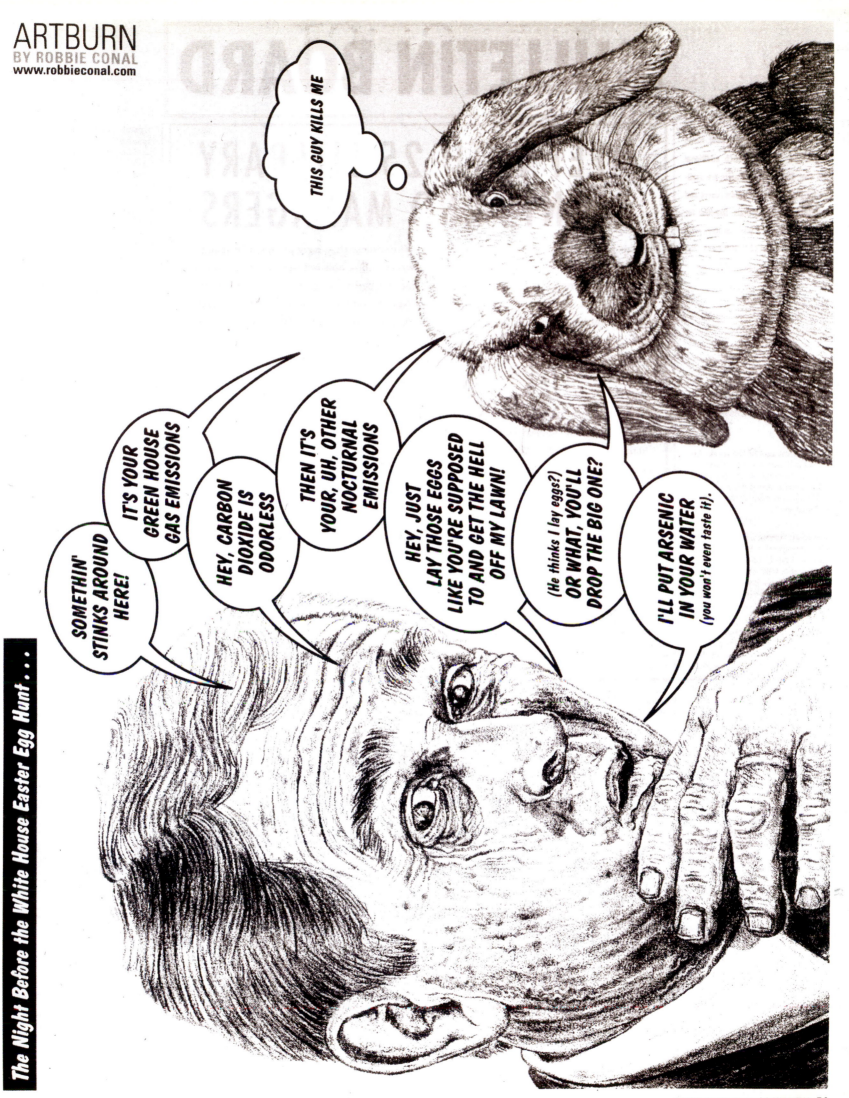

"*Conservation may be a sign of personal virtue, but it is not a sufficient basis for a sound, comprehensive energy policy.*"

—Dick Cheney, in a speech to the Associated Press Annual Meeting in Toronto, Canada, 5-01-01

Spoiled

This is an example of my failure of typographical nerve. "SPOILED" should be stretched out across the whole length of the page, dripping over all three of these characters. From George Senior's Gulf War to Junior's burning desire to turn the Alaskan wilderness into drilling fields—and now, AGAIN, turning Iraq into killing fields—to Dick Cheney, George Senior's Secretary of Defense during the Gulf War and ex-CEO of Halliburton: It's all about oil.

And God. Dubya can't seem to separate Church and State, just like he can't get over his dad's failures.

Originally conceived as a kind of greasy Easter thing, this piece went through several transubstantiations, finally becoming "The Second Scumming,"* a poster we took to Washington, DC in April 2001, just in time for the annual "Washington for Jesus" celebration on the Mall.

Needless to say, the posters weren't appreciated, but I did manage to fix the oily dripping type. Much to my chagrin, I still couldn't bear to cover up those ugly faces. Where are those cheesy Photoshop effects when you need 'em? Actually, Dave Shulman and I reconvened at "Anastasia's Asylum" (appropriately enough), a funky coffee house in Santa Monica, and whipped up some remixes. Plenty o' cheese there, baby. I still don't know how he came up with the typeface for "Sloppy Seconds."** Don't ask.

Spoiled: Father, Son, and the Holy Ghost
(Pictured: Bush Sr., Dubya, Dick Cheney)

*See page 76.

**See page 72.

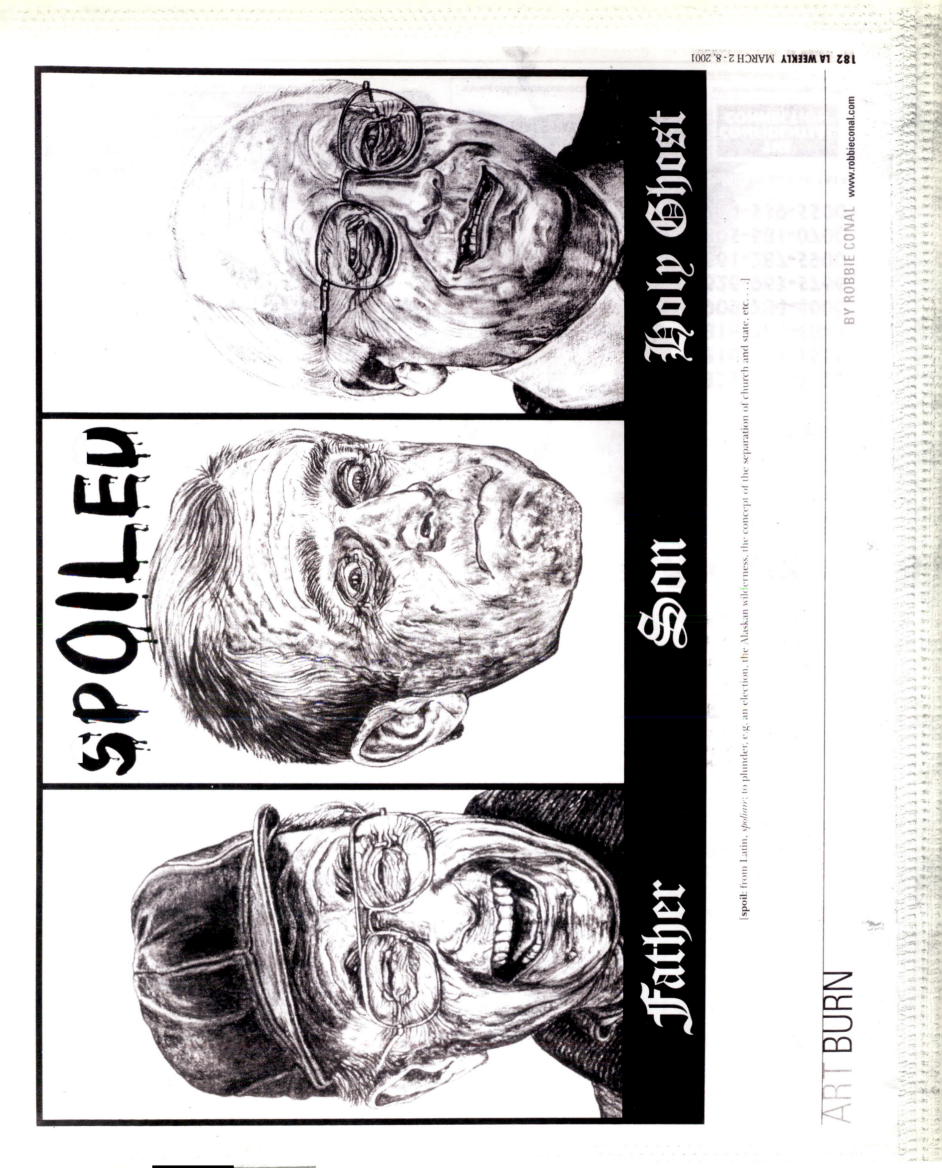

SPOILER

Father **Son** **Holy Ghost**

[**spoil:** from Latin, *spoliare:* to plunder; e.g. an election, the Alaskan wilderness, the concept of the separation of church and state, etc....]

BY ROBBIE CONAL www.robbieconal.com

ART BURN

The Grinch

The perpetual Florida tan. The life-threatening smile. The power suit. The accessories . . . No, they're not the problem. We've come to expect artificiality in our celebrities, especially politicians. It's battle gear. Think Trent Lott's hair.* But when a public official does what amounts to a public striptease of her character armor and she looks exactly the same . . . it only gets scary when what you see is actually what you get. Either Katherine Harris is The Grinch or she's a real-estate agent with some prime swampland in the Everglades that she knows we can turn into a theme park: "Pirates of the Electoral Process."

Well, she actually started as a realtor. And a good one.

Then in 1994 she became a state senator, receiving tainted big money from Riscorp, a Florida insurance company. The founder of the company pleaded guilty to federal conspiracy. Harris returned the money.

If she'd only returned the 57,700 Florida citizens she removed from the voter rolls in the 2000 Presidential election in Florida when she was Secretary of State, we might have a president who was actually elected by the people of the United States. She claimed they were all felons and therefore ineligible to vote. She's since been sued by the NAACP for disenfranchising black voters during that election.

Which is no big surprise. This is the dominatrix ringmaster behind the burning Bush Brothers' Florida tent show. She, more than anyone, gave us the dimpled butterfly ballot, the hanging chad, the pregnant chad, the hand count, the discount, the Republican goon squads, and that show-stopper: the geriatric "Jews for Buchanan." Dig this one: While she was Secretary of State, she co-chaired Dubya's

> **" Katherine Harris helped steal an election and didn't flinch or bat an eye. That's her legacy. "**
> —Molly Beth Malcolm, Texas State Democratic Party Chairperson

campaign in Florida and authorized a taxpayer-financed public service announcement ($30,000) featuring General Norman Schwartzkopf (a big Bush supporter) telling Floridians to vote. For whom? How many times?

*See Trent's rug on page 72.

The Grinch
(Pictured:
Katherine Harris)

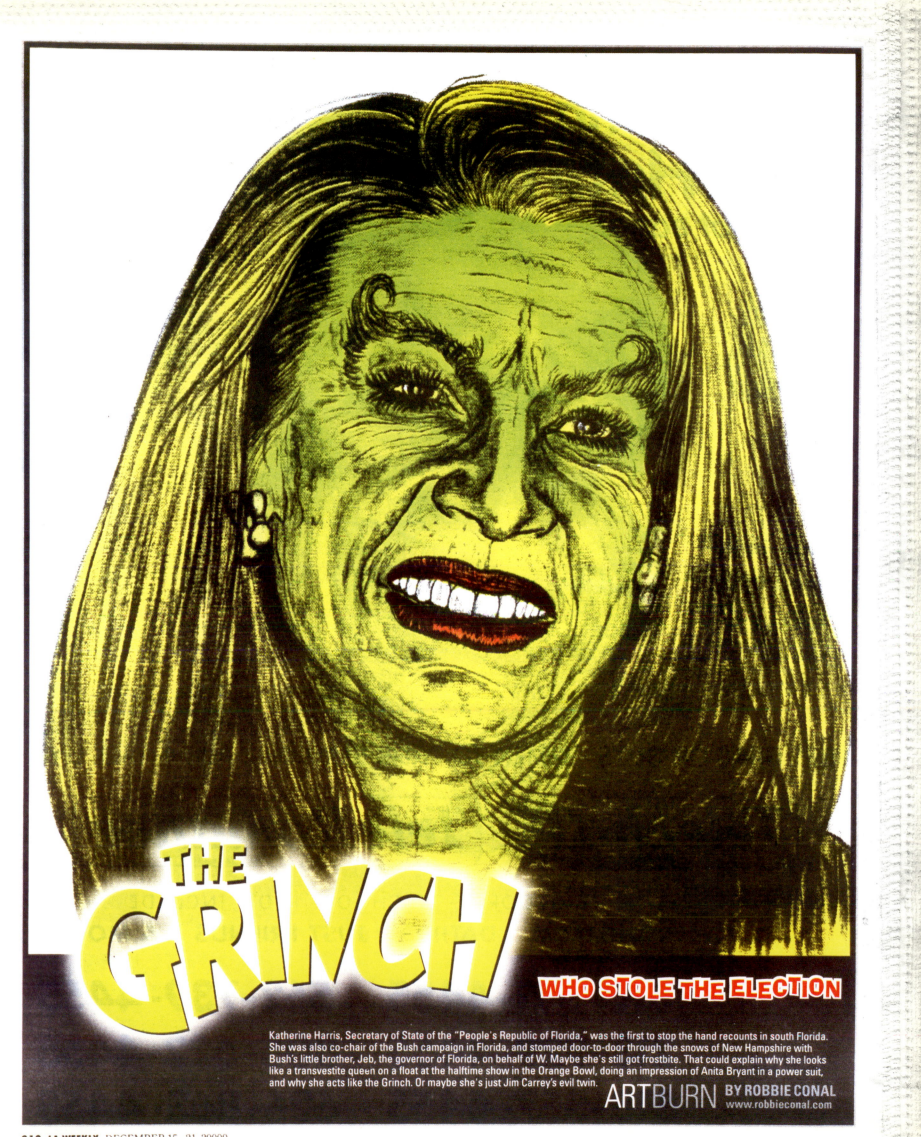

THE GRINCH

WHO STOLE THE ELECTION

Katherine Harris, Secretary of State of the "People's Republic of Florida," was the first to stop the hand recounts in south Florida. She was also co-chair of the Bush campaign in Florida, and stomped door-to-door through the snows of New Hampshire with Bush's little brother, Jeb, the governor of Florida, on behalf of W. Maybe she's still got frostbite. That could explain why she looks like a transvestite queen on a float at the halftime show in the Orange Bowl, doing an impression of Anita Bryant in a power suit, and why she acts like the Grinch. Or maybe she's just Jim Carrey's evil twin.

ARTBURN BY ROBBIE CONAL
www.robbieconal.com

> **"Why the Founding Fathers were dumb enough to have a president, I don't know. It worked while they were highly educated people, but they are getting worse all the time."**
> —Elaine Fantham, retired Princeton classical historian and NPR commentator

Tastes Like Chicken

The 2000 presidential election was a disaster for democracy on so many levels, it feels petty to focus on just one issue or candidate. So let's pick on both. My real problem with the electoral process in the U.S. is that two parties are not enough for real democracy. Put them together–Republicans and Democrats–all the representatives in the House, all the senators, and they still don't represent the majority of the people in America.

The first and only time I met Gloria Steinem, backstage at a Pearl Jam concert in Charlotte, North Carolina in '96, I immediately got into an argument with her. Idiot that I am. I'm still embarrassed about that conversation. She's so cool. She seemed to think that our elected officials in D.C. were sincerely trying to make things better for the majority of their constituents. I said that their real constituents were rich business people who gave them lots of money to represent their special interests. Oh well, that goes double for Gore the Bore and the Burning Bush.

Although I have to admit I was wrong about them being the same. Even the Bore couldn't be worse than Dubya.

This ARTBURN is a riff on the hand painted ads I'd see in butcher store windows on the upper west side of New York when I was a kid.

Specials of the week in primary colors, knocked out in an hour by awesome sign painters in poster paints on butcher paper, taped to the inside of the store windows. Gore and Bush selling themselves like USDA prime cuts of meat. And they're both white meat, baby. One's a chicken–won't take a stand on anything without his pollster's numbers up his ass. The other's a–well, what IS "the other white meat" anyway? Pork. Where does pork come from? Pigs.

Almost all the jive they laid on us about *difference* is high-paid propaganda. To put it in pop cultural, instead of purely economic, terms, bear with me while I mangle a sentence by A.O. Scott, from a review of the movie, *Head of State:* "The real division is . . . between a political culture built on blandness, sameness, and dishonesty, and a popular culture . . . that is polymorphous, candid, and profane."*

Not to run the voodoo down about the Electoral College (designed to circumnavigate the popular vote, duh!), or how close the whole election was (because how can you choose when there's so little choice?), or the butterfly-ballot design, or how stolen it was (by none other than the Supreme Court). Democracy? Not.

*New York Times, 3-28-03

Tastes Like Chicken / The Other White Meat
(Pictured: Al Gore, Dubya)

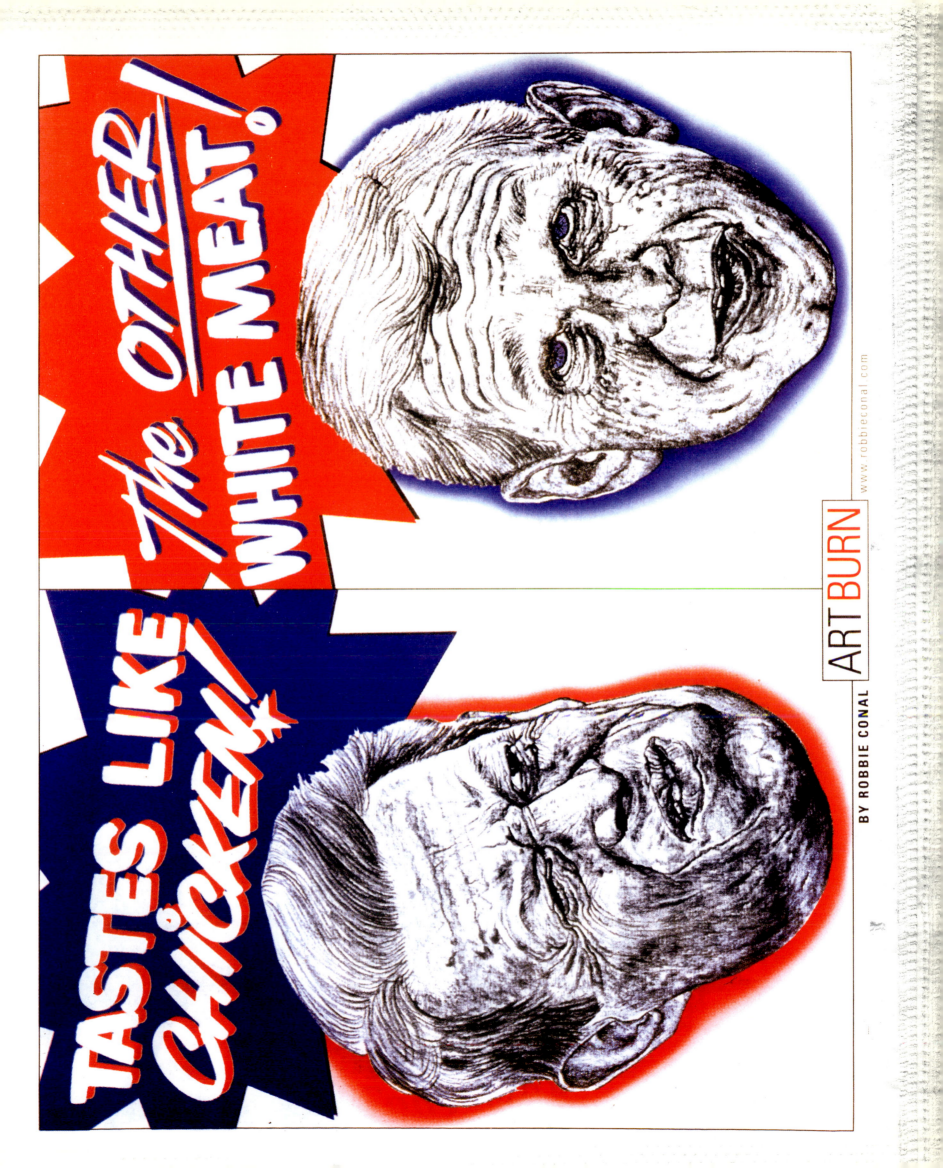

The OTHER WHITE MEAT!

TASTES LIKE CHICKEN!

ART BURN

BY ROBBIE CONAL

Eat More Possum

I don't really know what "Eat More Possum" means, but it sounds right for John Rocker, ex-Atlanta Brave, ex-Cleveland Indian, present Texas Ranger (last in the American League) pitcher.

He could just look up a recipe in the *White Trash Cookbook*, prepare a mess of it, and stuff that possum into his mouth (I hear the fur is especially tasty), along with both his feet that are already in there.

Johnny doesn't like anyone who doesn't look or think exactly like him—luckily there aren't many people on the planet who qualify. How many good old boys are there from Statesboro, Georgia with very little education, who make $2.5 million a year for throwing a baseball and think they're really a World Wrestling Federation super-hero, "The Talking Asshole"? That's a rhetorical question.

"*The biggest thing I don't like about New York are the foreigners. I'm not a very big fan of foreigners. You can walk an entire block in Times Square and not hear anybody speaking English. Asians and Koreans and Vietnamese and Indians and Russians and Spanish people and everything up there. How the hell did they get into this country?*"

—John Rocker, as quoted in *Sports Illustrated*

Eat More Possum

(Pictured: John Rocker)

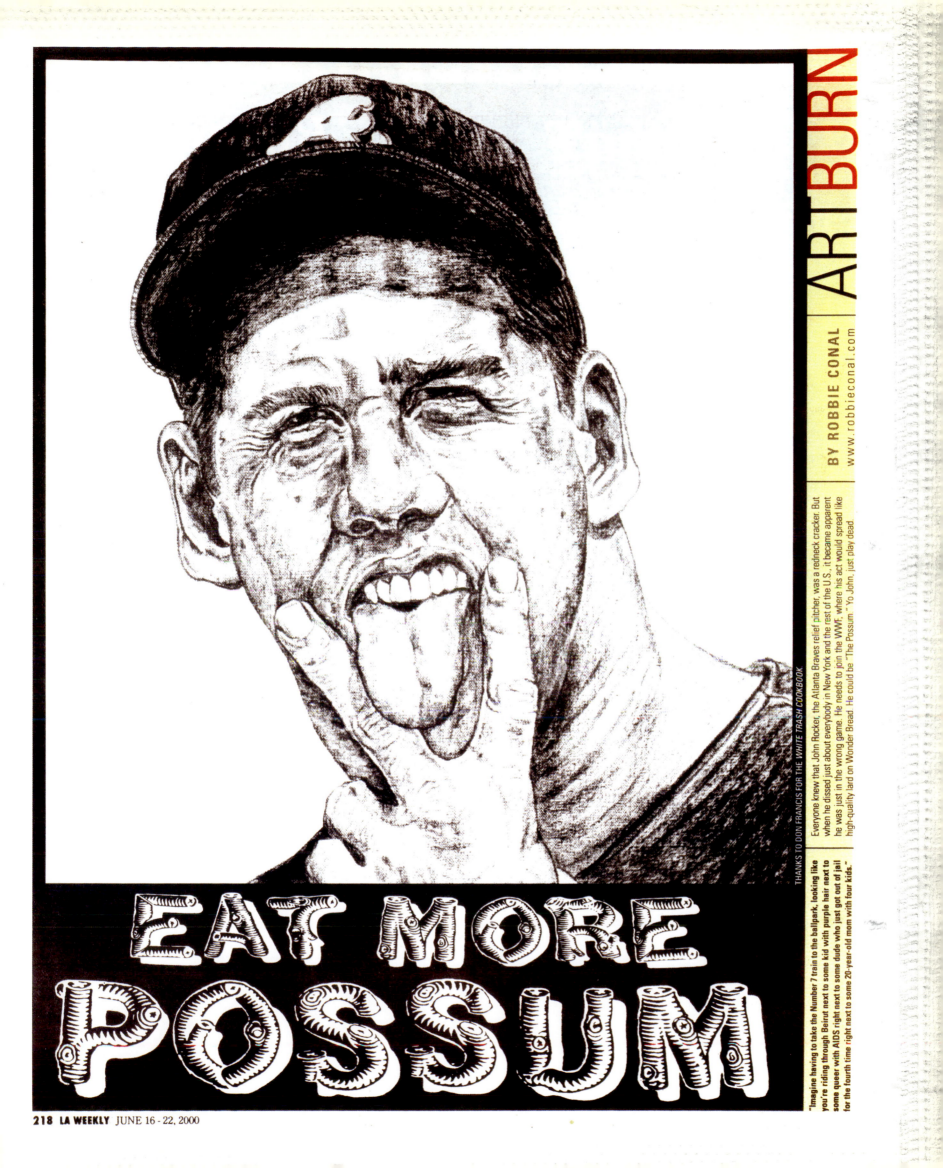

THANKS TO DON FRANCIS FOR THE *WHITE TRASH COOKBOOK*

Everyone knew that John Rocker, the Atlanta Braves relief pitcher, was a redneck cracker. But when he dissed just about everybody in New York and the rest of the U.S., it became apparent he was just in the wrong game. He needs to join the WWF, where his act would spread like high-quality lard on Wonder Bread. He could be "The Possum." Yo John, just play dead

"Imagine having to take the Number 7 train to the ballpark, looking like you're riding through Beirut next to some kid with purple hair next to some queer with AIDS right next to some dude who just got out of jail for the fourth time right next to some 20-year-old mom with four kids."

EAT MORE POSSUM

> **"Tonight I am here to salute a truly unique woman, who has done more to galvanize the gay and lesbian community and their supporters than even she knows, a woman who has united us and inspired us to action. I'm talking, of course, about the one and only Dr. Laura Schlessinger. [Hoots and catcalls] If only she were here to have heard that outpouring of affection. Dr. Laura, thank you for bringing us all together."**
> —Julia Louis-Dreyfus, at the GLAAD Media Awards, Los Angeles*

Orthodoxymoron

Dr. Laura has been on talk radio since 1990. Her show's been internationally syndicated since 1994. She's a proponent of "tough love," and she's right about that: She's tough to love. She'd been estranged from her mother since 1986, when Mom quit as Dr. Laura's secretary, but the family never got on well. Dr. Laura has said, "I have a background that would curl your hair." Her foreground, on the other hand, would straighten it right out. Although the good Doctor has no degree in psychotherapy, she gives all kinds of "lifestyle" advice, even though she only believes in one lifestyle: her own. And she looks like the living dead—which isn't the reason her syndicated TV show was cancelled on March 29, 2001, seven months after its premiere. It's because she called homosexuality, "a biological error" and "an abomination." A Jew whose orthodoxy extends mostly to funda-mentalist Christian-style family values, she's been called "a positive voice for positive values without equal in our time" by the Reverend Robert Schuller of the Crystal Cathedral in Orange County, California.

There are certain words and phrases that I always wanted to use in some piece or other. "Oxymoron" tops the list. It would have been perfect for international oil baron and art collector Armand Hammer, the late boss of Occidental Petroleum. In Dr. Laura's case, orthodox and moron kept calling her name. *Orthodox* comes from a conflation of the Latin, *orthos*, correct, and *dox*, opinion. Rub those two words together and they really make for more of a conflagration. *Moron* comes from the Greek *moros*, foolish. It is indeed foolish—one might say *oxymoronic*—to insist that people live their lives based on your correct opinion.

*As reported on PlanetOut.com, http://www.planetout.com/entertainment/starstruck/2000/05/lauraquotes.html.

All these facts are stolen from Jill Levoy's and Mitchell Landsberg's great article in the *Los Angeles Times*, 12-21-02.

Orthodoxymoron
(Pictured: Dr. Laura Schlessinger)

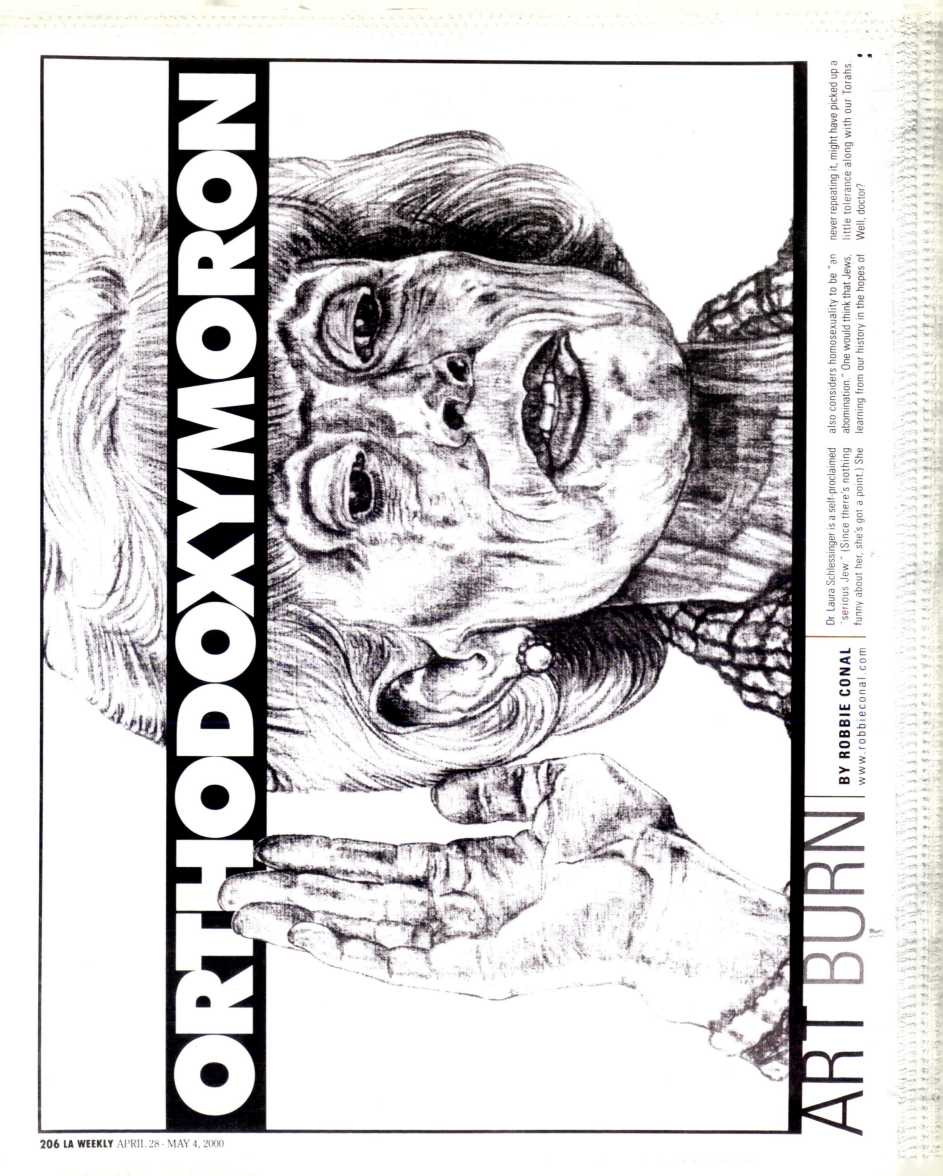

ORTHODOXYMORON

ARTBURN

BY ROBBIE CONAL
www.robbieconal.com

Dr. Laura Schlessinger is a self-proclaimed "serious Jew." (Since there's nothing funny about her, she's got a point.) She also considers homosexuality to be "an abomination." One would think that Jews, learning from our history in the hopes of never repeating it, might have picked up a little tolerance along with our Torahs. Well, doctor?

"One of the great things about books is sometimes there are some fantastic pictures."

–G. W. Bush, *U.S. News & World Report*, 1-03-00 (as quoted in *Bushisms*, edited by Jacob Weisberg)

Pet Peeve: Barb & Millie

I wanted to use this quote on the back jacket of this book–kind of as a left-handed compliment–but I got voted down by my right-handed handlers.

Years after a fancy, expensive, but dubious (Dubyaous?) education, Dubya actually learned to read–his speechwriters' words. Way too well, by my reckoning. But he still can't talk extemporaneously. He probably can't even spell that word. Obviously, his lack of verbal agility hasn't hurt his rise to power. (As Robin Williams says, "Some men are born great, some achieve greatness, some get it as a graduation gift.") But it does make him hard to listen to. I've been a Lakers fan for years, but whenever they were on national TV, I would watch them with the sound turned off and tune the radio to Chick Hearn, who knew what he was talking about. I can't even watch Dubya with the sound turned off.

Since Dubya likes pictures so much, Bill Smith and I got the bright idea to remix this Pet Peeve drawing to include him. We know that Barbara started the Barbara Bush Foundation for Family Literacy (that would include Dubya, wouldn't it?), so we turned it into a comic, something Dubya might actually pick up to "read." Kind of help Bar along with the family. Not that Bar hasn't had major successes, like getting her dog Millie to write a book. I figure, since she was so hep on family literacy, she must have tried to draft Millie into her campaign to teach Dubya. However, even Millie knows her (and his) limitations.

Pet Peeve

(Pictured: Barbara Bush and Millie)

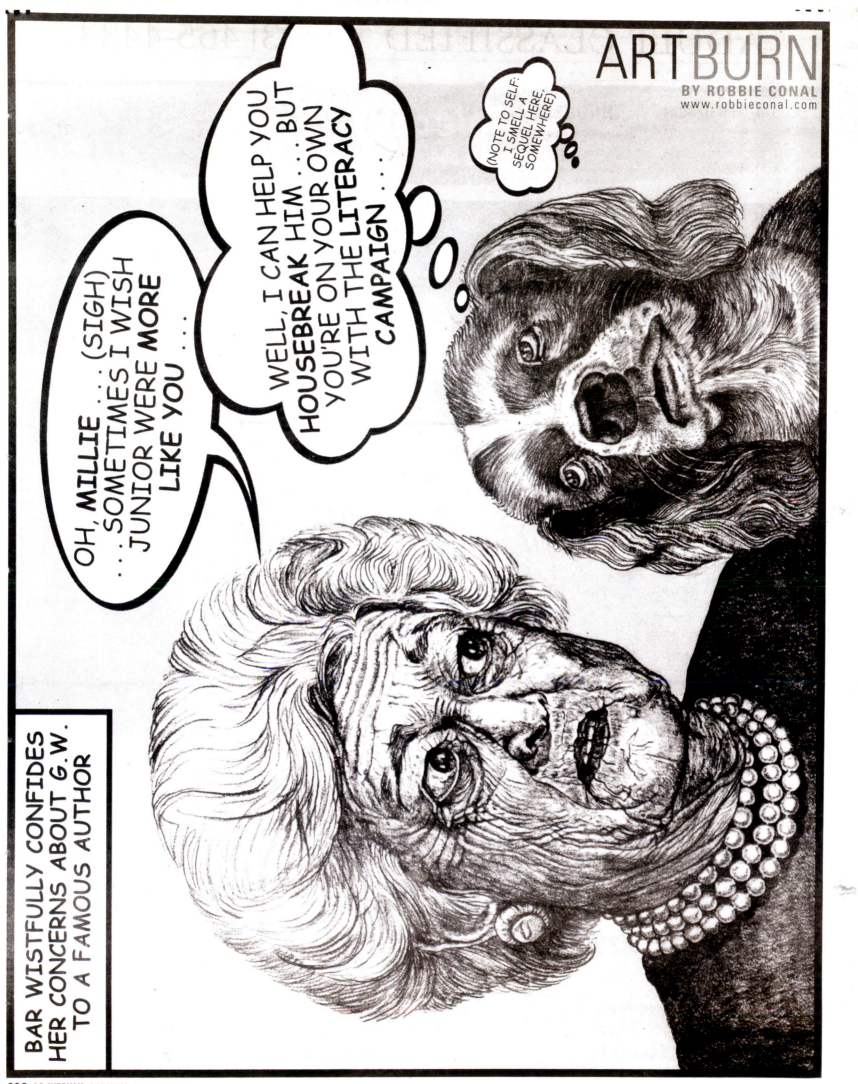

BAR WISTFULLY CONFIDES HER CONCERNS ABOUT G.W. TO A FAMOUS AUTHOR

> **"Rush Limbaugh never lets the facts get in the way of a good rant. His program has successfully tapped into that elusive 18-35-year-old Klan demographic."**
> —Janeane Garofalo

Liposuction

Alfred Hitchcock supposedly once said, "The way to get rid of fat is to cut it off." These days it's only Rush's brain and mouth that are fat. With Rush, of course, they're the same organ. Some of his syndicators know this and have been cutting away at his radio program.* Unfortunately, they're just snipping for dollars, using a computer program called "Cash"–cutting wind, so to speak–to make more advertising time. This upsets Rush. I'm not sure why . . . Maybe something to do with how much he values his pregnant pauses. It could be a "right to life" thing: He believes that even his unborn words are alive with meaning.

What upsets me about him is that he was originally turned into a media star as an ersatz redneck shill for the first Bush. Workin' the workin' class.

And nothing's changed. Ultra-conservative Capital Cities bought ABC TV in 1985. William Casey–CIA director from '81-'87; anyone remember Iran Contra?–was one of its original founders. In '88, ABC flushed Rush out of

Sacramento, where he'd been a hit defending Ollie North on local radio. He went national, to WABC in New York, then to *Nightline* (yes, with Ted Koppel), *Donahue*, and ABC's *20/20* (yes, Baba Wawa). Roger Ailes, Bush Senior's media advisor, produced Rush's TV show, which debuted two months before the '92 election. The show was so biased, he was asked to give equal time to his opponents. He answered, "I am equal time." Lest we forget how big he really is.

Of course, now Disney owns ABC and Rush is as big as a Thanksgiving Day parade balloon. He wants to be like Mickey. And he is. Liposuction has replaced Hitchcock's scalpel (though not his rapier wit). But I'm still happy to see some air taken out of Rush's air.

The graphic style of this ARTBURN was an hommage to Barbara Kruger, one of the greatest American artists to address social and political issues. She and Sue Coe have been heroes (heroines?) of mine ever since I started making posters.

*Source for all of this: Dennis Mazzocco, *Networks of Power* (Boston: South End Press, 1994).

Liposuction
(Pictured:
Rush Limbaugh)

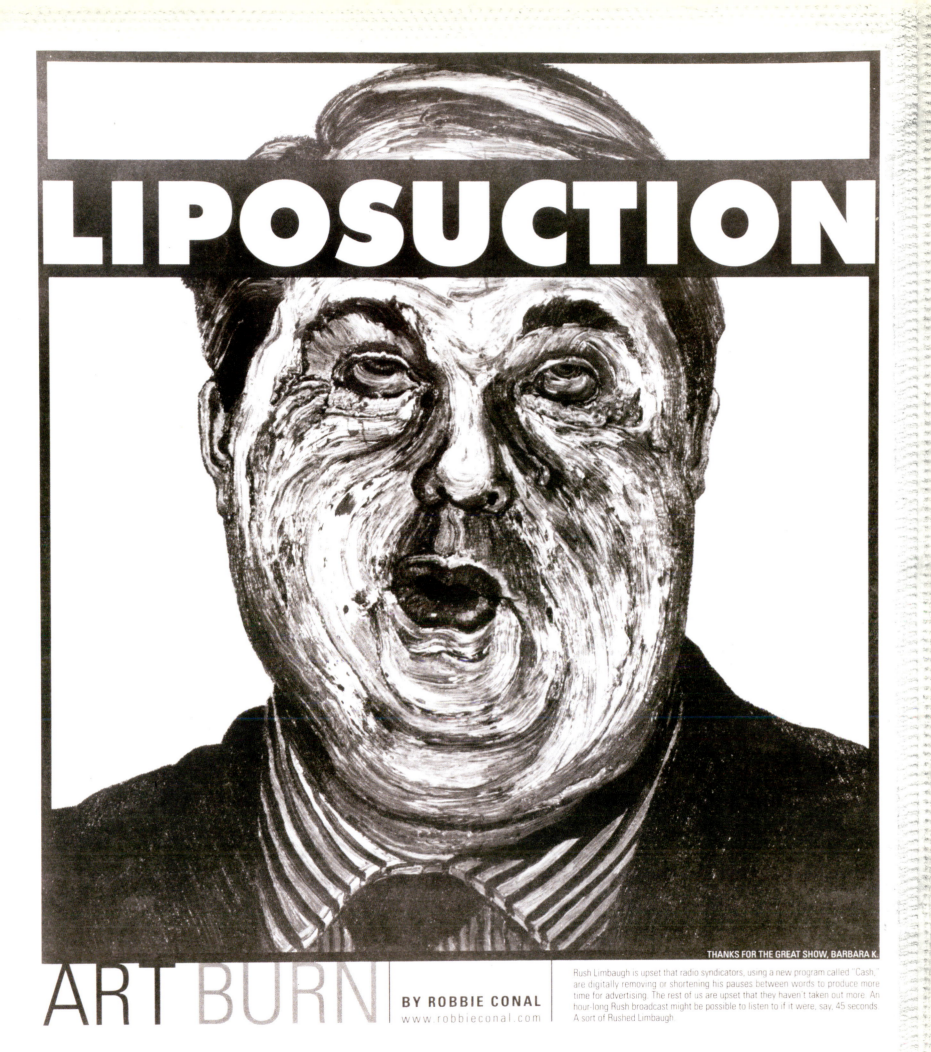

LIPOSUCTION

THANKS FOR THE GREAT SHOW, BARBARA K.

ART BURN

BY ROBBIE CONAL
www.robbieconal.com

Rush Limbaugh is upset that radio syndicators, using a new program called "Cash," are digitally removing or shortening his pauses between words to produce more time for advertising. The rest of us are upset that they haven't taken out more. An hour-long Rush broadcast might be possible to listen to if it were, say, 45 seconds. A sort of Rushed Limbaugh.

> **" First of all, I want to say how delighted I am to be here representing the great state of . . . ah . . . ah . . . ah . . . ah. "**
>
> —Bobby Kennedy (Hillary's carpetbagging role model) speaking to the Women's National Press Club, the night he was sworn in as Senator from New York in 1965 (He was kidding)

Home Sweet Homie

From a "buy one, get one free" presidency; to a shtick of: stick Bill in the carpetbag and hightail it to a $1.7 million white house in Chappaqua, New York in time to run in the senatorial election; to settling into the Senate with one eye on the shoppers' special train schedule into the city and the other still on her old White House, Hillary's been a veritable multi-tasking Wonder Woman. No *wonder* she never had time to consider the consequences of her hubby's position on Vieques Island, Puerto Rico (where she probably would have preferred to park him) in relation to her Latino constituency in the Big Apple. President(s) Clinton refused to order a permanent end to military target practice on the Puerto Rican island, home to 9,300 civilian U.S. citizens. (See, there's another reason Hillary might have liked to drop Bubba there: the target practice thing.) It did not play well in "El Barrio." I hate to mention it, but if Rudy Giuliani had stayed in the race, she might have lost on that issue alone (the polls were close). Of course, if she had just taken a walk around East Harlem while she was campaigning, she'd have known better. Or at least known something.

> **" She comes from TV. She's not from anywhere. "**
>
> —Dr. Lee Miringoff, director of the Marist Institute for Public Opinion

This kind of political opportunism isn't new. Bobby probably learned it from his big brother, JFK, who, when he was running for a congressional seat in Boston in '46, used a rented hotel room as his official residence in the 11th District.

The basic idea here, aside from using any excuse to do some cheesy Photoshop needlepoint effects, is that it's generally better for democracy when a representative knows the people he or she is representing—and not only the wealthy neighbors. Just a thought.

Home Sweet Homie
(Pictured:
Hillary Clinton)

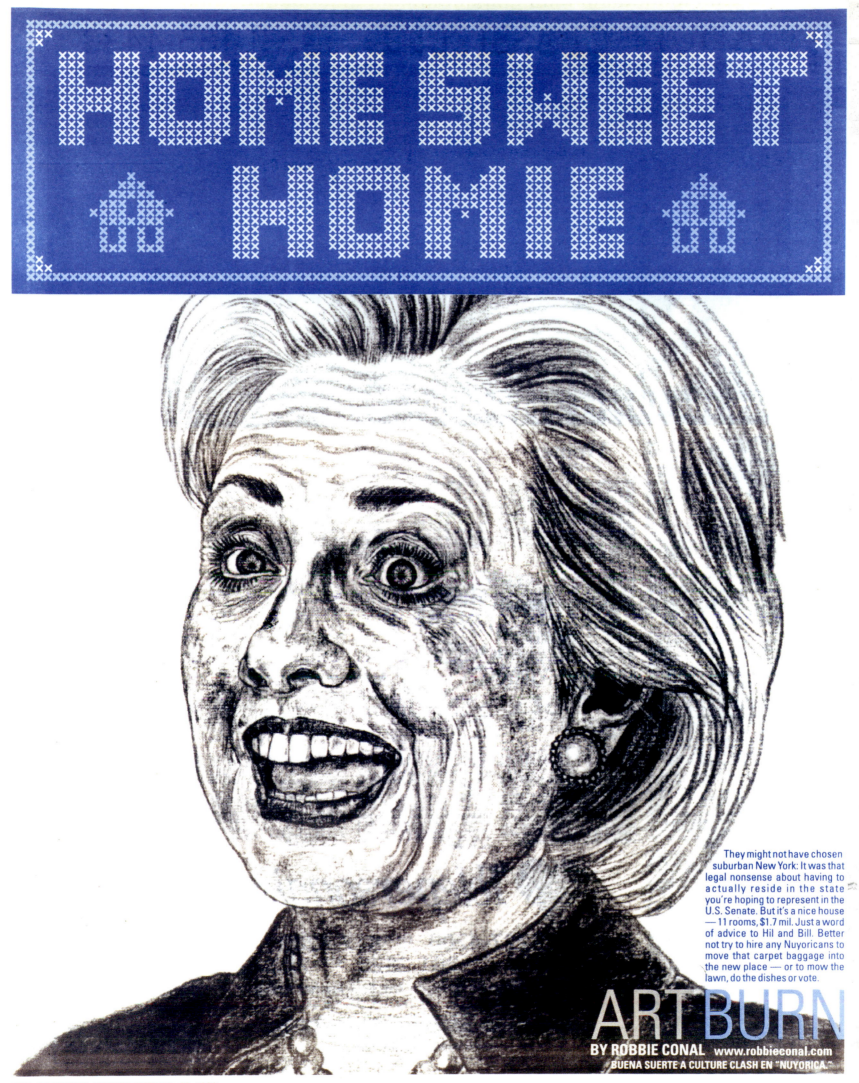

HOME SWEET HOME

They might not have chosen suburban New York: It was that legal nonsense about having to actually reside in the state you're hoping to represent in the U.S. Senate. But it's a nice house — 11 rooms, $1.7 mil. Just a word of advice to Hil and Bill. Better not try to hire any Nuyoricans to move that carpet baggage into the new place — or to mow the lawn, do the dishes or vote.

ART BURN

BY ROBBIE CONAL www.robbieconal.com
BUENA SUERTE A CULTURE CLASH EN "NUYORICA."

Animusclemania

No history. No art. No statement. But "Egos R Us." When Chairman of Disney Studio, Jeffrey Katzenberg, was passed over for the Chief Operations Officer position after Frank G. Wells died, he must have realized he wasn't Snow White after all. Feeling unappreciated by his boss, Michael Eisner, he left in a Grumpy huff, bringing a $250 million lawsuit against "Mauschwitz" along for the ride.

But these guys know entertainment. After all, they ruled the Magic Kingdom. So–POOF!–it was easy for them to turn a mere courtroom into the center ring of a WWF winner-take-all spectacle. Transforming the bout into a mutual striptease, they showed us what they were really made of: greed and hubris.

Which is a good lesson for the likes of us Angelenos, who breathe what other people call smog, but is really the narcotic effluvia of the production capital of popular culture. At this level of corporate capitalism, there are no nice guys. Eisner, ever the lovebug, has famously said about Katzenberg, "I hate the little midget." As well as famously homogenizing Disney's parasitic content (I can't even look at

their Winnie the Pooh–it's those dumbed-down drawings; where's E.H. Shepard when we need him?), Disney is notoriously cheap–just ask those people in Mickey suits or companies that do business with the Big Rat

> ## "We have no obligation to make history. We have no obligation to make art. We have no obligation to make a statement. To make money is our only objective." *
>
> —Michael Eisner, as quoted in *Bio Rats Out Head Mouse Eisner,* by Bridget Byrne, E-Online, 5-17-00

Factory. Working with Disney is so difficult that Coca-Cola, AT&T, Delta, and Kodak held informal meetings to trade tactics for coping with Eisner and company.** And check out Katzenberg's rep around town: Brenda Chapman, director of *The Prince of Egypt* and art director of *The Lion King*, has said, "I'd seen him rip the heads off directors and just leave bloody stumps." Sweet.

*From 1996 to 2001, Eisner has made $737 million. About 19 times the $38 million made by the average CEO on Forbes.com's First Annual CEO Value Survey (www.forbes.com/2001/04/26/eisner.html).

**Marc Gunther, "Eisner's Mousetrap," *Fortune Magazine*, 9-99.

Animusclemania

(Pictured:

Michael Eisner and

Jeffrey Katzenberg)

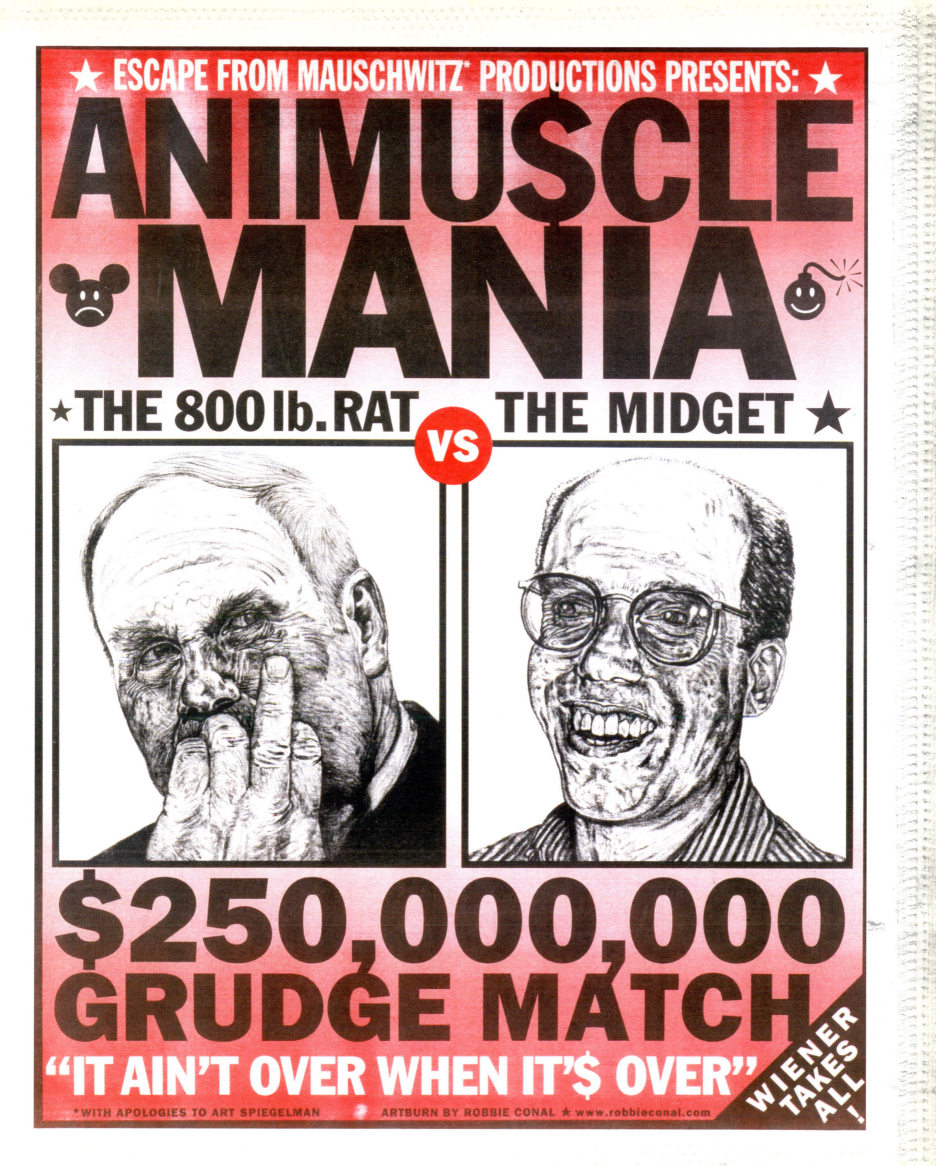

> **"To a hushed room of a thousand average American stockholders, I simply read the full lyrics of 'Cop Killer':**
>
> **I got my 12-gauge sawed off
> I got my headlights turned off
> I'm about to bust some shots off
> I'm about to dust some cops off . . .**
>
> **It got worse, a lot worse. I won't read the rest of it to you."**
>
> —Charlton Heston, in a speech to the Harvard Law School Forum, 2-16-99

Guns 'N' Moses

The lyrics are from Ice–T! The problem is, Chuckie would go along with three out of four of them–it's really just a question of who'd be the target. As in: you, me, or the Red Sea. Basically, Chuckie is deep into, "*Noli Me Tangere*," translated loosely as, "Don't fuck with me or my shit, or I'll blow your brains out." In other words, he's a true believer in personal freedom. The old timer has seen it all; heck, he's *been* it all. Not just Moses, Ben-Hur, and Michelangelo, but also in so-called real life. He was a liberal New Deal Democrat in the forties, and wore a sandwich board sign–"All Men Are Created Equal"–in a civil rights march in Oklahoma City (!) in '61. As he put it, "I've attended more rallies and appeared before more public forums than anyone other than Jane Fonda. I see nothing wrong with actors speaking out on causes . . . The only obligation we have is not to make horses' asses of ourselves."* Ahem! I can't figure out why this very public man transmogrified over 50 years into a conservative Republican. Maybe he (and his values) just ossified. Maybe we can blame it all on his old acting buddy, President Ronald Reagan. Chuckie headed Ronnie's task force on the arts and humanities. Hmmm, kind of like Jesse Helms heading up the NEA. Heston became President of the National Rifle Association in 1998. In real life, he'd part the Red Sea with friendly fire from an M-16. These days he and his new best friend, John Ashcroft, are busy conflating the First Amendment and the Second Amendment. After all, Chuckie believes that all American children "have the right to choose to own a gun–a handgun, a long gun, a small gun, a large gun, a black gun, a purple gun, a pretty gun, an ugly gun."**

*Quoted by Vic Gold, *The Washingtonian*, 6-82.

**Speech to National Press Club, 9-11-97.

Guns 'N' Moses

(Pictured:

Charlton Heston)

GUNS 'N' MOSES

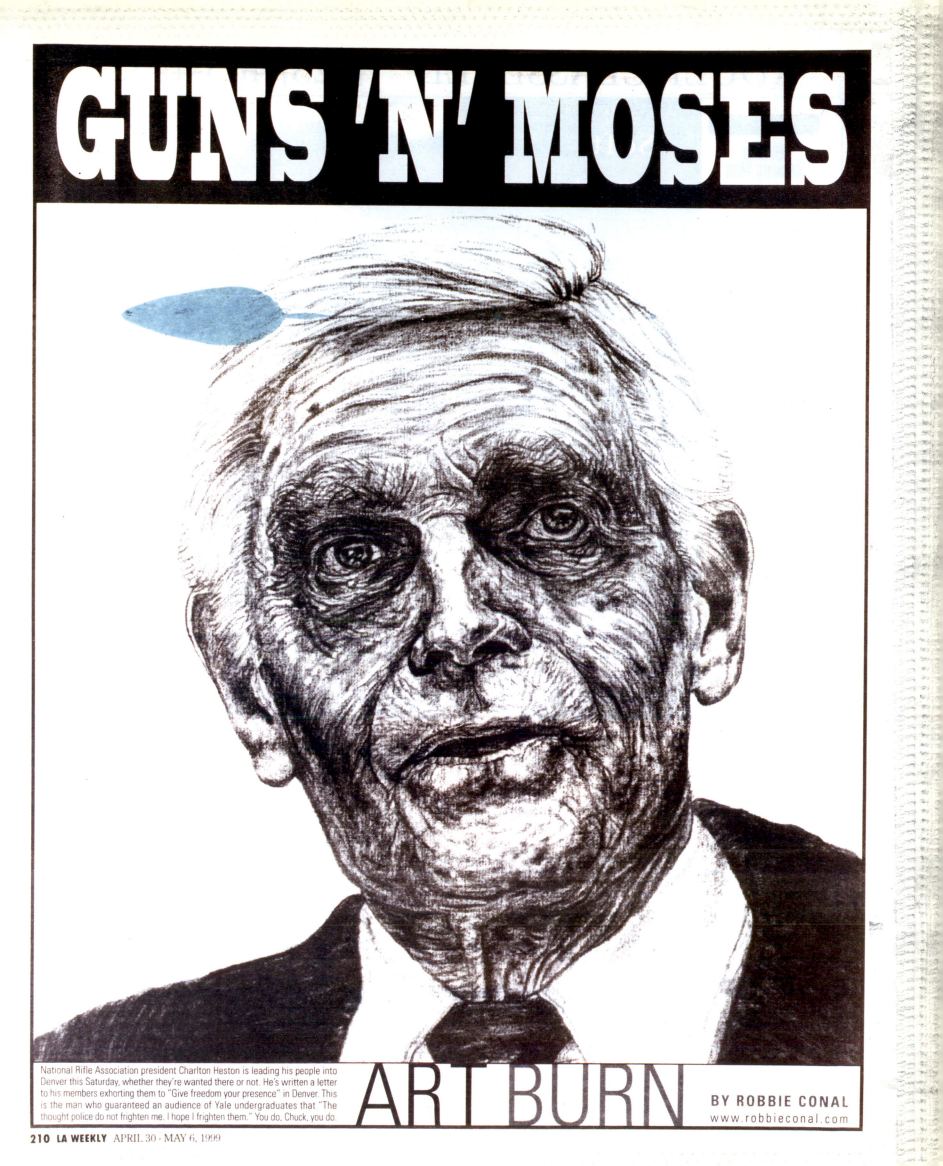

National Rifle Association president Charlton Heston is leading his people into Denver this Saturday, whether they're wanted there or not. He's written a letter to his members exhorting them to "Give freedom your presence" in Denver. This is the man who guaranteed an audience of Yale undergraduates that "The thought police do not frighten me. I hope I frighten them." You do, Chuck, you do.

ART BURN

BY ROBBIE CONAL
www.robbieconal.com

Caveat Empty

As in, there's no there *there* . . . Bubba's been raptured. Blown right out of his job. He's arguably the most talented politician of our era. Such a waste of talent. But maybe Bubba's fatal flaw isn't really big-haired, full-sized temptresses. Or making Little Kenny Starr jealous. It's lying to the American people. Which just might be a manifestation of the hubris that comes with the territory. This is not an excuse, it's a condition. Democracy can't take much more of all the hypocrisy demanded by the temptations of so much power. Bubba thought he had too much to lose by telling the truth. (He was wrong about that. The saving grace of the American people is that we're so stunned by honesty and apology coming from powerful people that we will quickly forgive them. At least once.)

I'm not saying that you can't come up from the streets or out of the trailer park and be a player. It's just that on your way up, you're gonna get bought. Or buy in.

I know we have elections, two whole competing parties–hey, we're Americans. Competition is what it's all about. But between whom? Bubba and Bob "Viagra" Dole? Gore the Bore and Dubya?

We also have an Electoral College, designed to prevent the rabble (that's most of us) from taking over the government. We all took that class, "Elections 101," in 2000, right? Eventually, there's just too much at stake. How about proportional elections? They can't be less democratic than what we've got. But in our society, everything gets so blown out of proportion. In a larger sense, true democracy and the control of the richest, most powerful nation in

the world don't work together very well.

We have a capitalist democracy, which translates into "you get what you pay for," which transmogrifies under the pressure of the profit motive into exploitation, secrecy, and deceit: "Let the buyer beware."

Caveat Empty

(Pictured:

Bill Clinton)

CAVEAT EMPTY

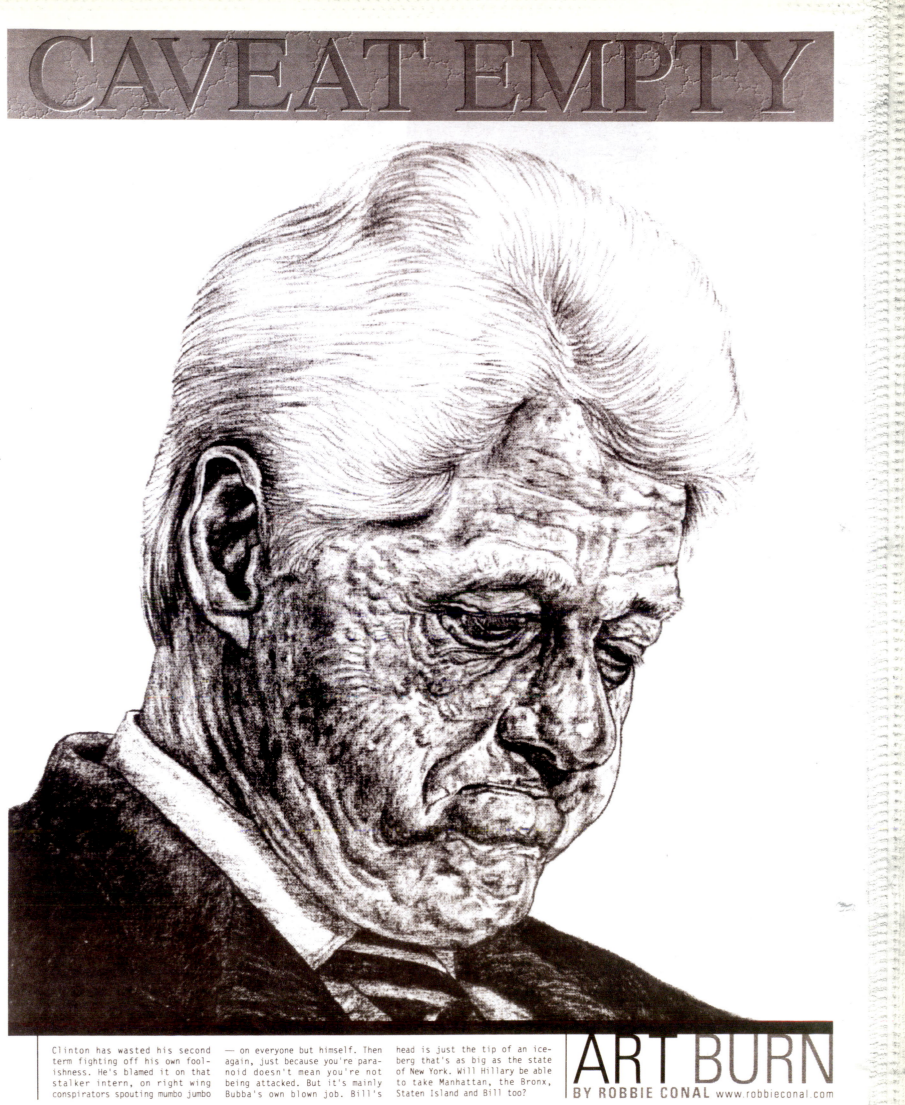

Clinton has wasted his second term fighting off his own foolishness. He's blamed it on that stalker intern, on right wing conspirators spouting mumbo jumbo — on everyone but himself. Then again, just because you're paranoid doesn't mean you're not being attacked. But it's mainly Bubba's own blown job. Bill's head is just the tip of an iceberg that's as big as the state of New York. Will Hillary be able to take Manhattan, the Bronx, Staten Island and Bill too?

ART BURN
BY ROBBIE CONAL www.robbieconal.com

Jumbo Mumbo

Ergo, crimes of the heart: At the heart of the Iran Contra scandal, summer of 1986, the great Jumbo Mumbo was on the House Intelligence Committee when Ollie North said it wasn't so. Ollie and the National Security Council were not overseeing a secret op in Nicaragua. Certainly not. That was good enough for Jumbo.

On October 5, one of Ollie's planes was shot down over Nicaragua, proving Ollie had perjured himself.

Instead of expressing his "love [for] the rule of law," Jumbo Mumboed his defense of Ollie's lies. After all, Ollie quoted Thomas Jefferson: "A strict observance of the written laws is doubtless one of the high duties of a good citizen, but it is not the highest. The laws of necessity, of self-preservation, of saving our country when in danger are of higher obligation."

Well, first of all, aiding the Contras was not a case of saving our country. Secondly, dig that crazy line about SELF-PRESERVATION. That's what Jumbo was (and is still) really Mumboing about. He could be the personification of that great blustering animated rooster, Foghorn Leghorn.* "Ah say, ah say, cut that out, what's it all about boy, *elucidate*!" Gladly:

Henry Hyde was the only member of Congress sued by the government for his perpetrations as a board member in the failure of the Clyde Federal S&L in Illinois ($67 million down the tubes). It had started as an S&L investigation you might remember: Whitewater. He refused to pay his part of the $850,000 settlement. That's Jumbo Mumbo!

" *This is not a question of who we hate, it's a question of what we love. And among the things we love are the rule of law...***"**
—Henry Hyde (House Representative from Illinois for 29 years), in a speech to the Senate during its Clinton impeachment trial

Nuttiest of all is Jumbo's Mumboing on and on about Clinton's blown job with Monica and his subsequent lying to Congress about it. Our country was definitely in danger because of the secret perpetration of fellatio.

And he should know. From 1965 to 1969, Hyde carried on an adulterous affair–he was married and had four children by that time. Of course, he kept it secret, lying to his Illinois constituency (he served in the Illinois House from 1966-74) and his family, until his lover's husband paid a visit to his wife. Jumbo Mumboed that it was just his "youthful indiscretion." He was 41 when the affair began. At least we know what he means by "the things we love..."

As for the two-handed measuring gesture pictured across the page, Jumbo is Mumboing about the size of his...conscience.

Jumbo Mumbo
(Pictured:
Henry Hyde)

*The actual prototype for Foghorn was Kenny Delmar's "Senator Claghorn" on the great Fred Allen radio show. Close enough.

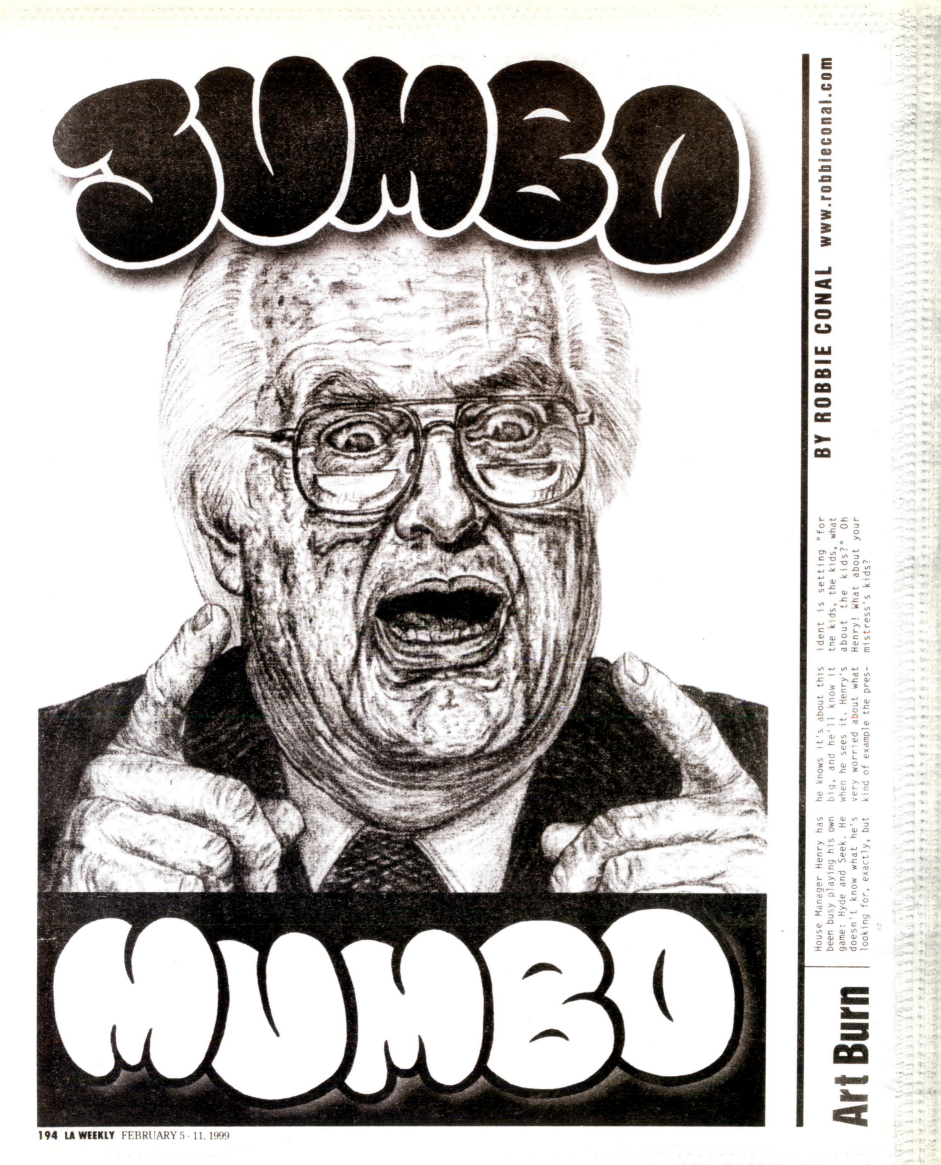

JUMBO
MUMBO

BY ROBBIE CONAL www.robbieconal.com

House Manager Henry has been busy playing his own game: Hyde and Seek. He doesn't know what he's looking for, exactly, but he knows it's about this big, and he'll know it when he sees it. Henry's very worried about what ident is setting "for the kids, the kids, what about the kids?" Oh Henry! What about your mistress's kids?

Art Burn

"For Immediate Release, July 25, 2002. Chairman Burton [R-IN] Introduces Legislation to Remove J. Edgar Hoover's Name From the FBI Building. 'J. Edgar Hoover clearly abused his role as Director of the FBI. Symbolism matters in the United States, and it is wrong to honor a man who frequently manipulated the law to achieve his personal goals.'"

—Press release from the office of Dan Burton (R-IN), Chairman of the Committee on Government Reform, U.S. House of Representatives

Pet Peeve:
J. Edgar Hoover

Would J. Edgar Hoover love the "Office of Homeland Security," or what? How hard would he get, manipulating Washington, D.C.'s "Joint Operation Command Center of the Synchronized Operations Command Complex"?

When we contemplate the dialectics of the most secretive law-enforcement agency in the land dueling the likes of the Mafia—USING SIMILAR TACTICS—it gets a little hard for us, too. Hoover's ghost is probably drooling right now, contemplating the parallels between the business culture of "Gangsta Rap" and *The Godfather* saga. He could go undercover. Think how great he'd look as a cross-dressing "Snoop Dogg"!

Hoover is another of my Pet Peeves. A half century of wire-tapping everybody, red-baiting, blackmail, and deeply closeted homosexuality—lest we forget, he had so many guys' balls in his pockets, he had to buy closets full of corsets to hide the bulge—makes him Richard Milhous Nixon's feminine side, or his evil twin. Think if he'd only come out: an openly gay FBI Director in the fifties. A true G-man! What a triumph that would have been for the Bill of Rights! (Of course, it would have also proved that I'm living in a parallel universe.) Hoover had it in for everybody, yet no

"**Hoover didn't associate with people unless he had something on them. Mervyn LeRoy, for example, was approved as director of the movie version of The FBI Story only after Hoover was satisfied that 'we had enough dirt to control him.'**"

—Curt Gentry, *J. Edgar Hoover, the Man and the Secrets*, p. 384 (NY: W.W. Norton & Co., 1991)

one was more full of self-hate. Ah, but he loved his dog. And they looked exactly alike. Poor doggy.

Pet Peeve

(Pictured: Dog and J. Edgar Hoover)

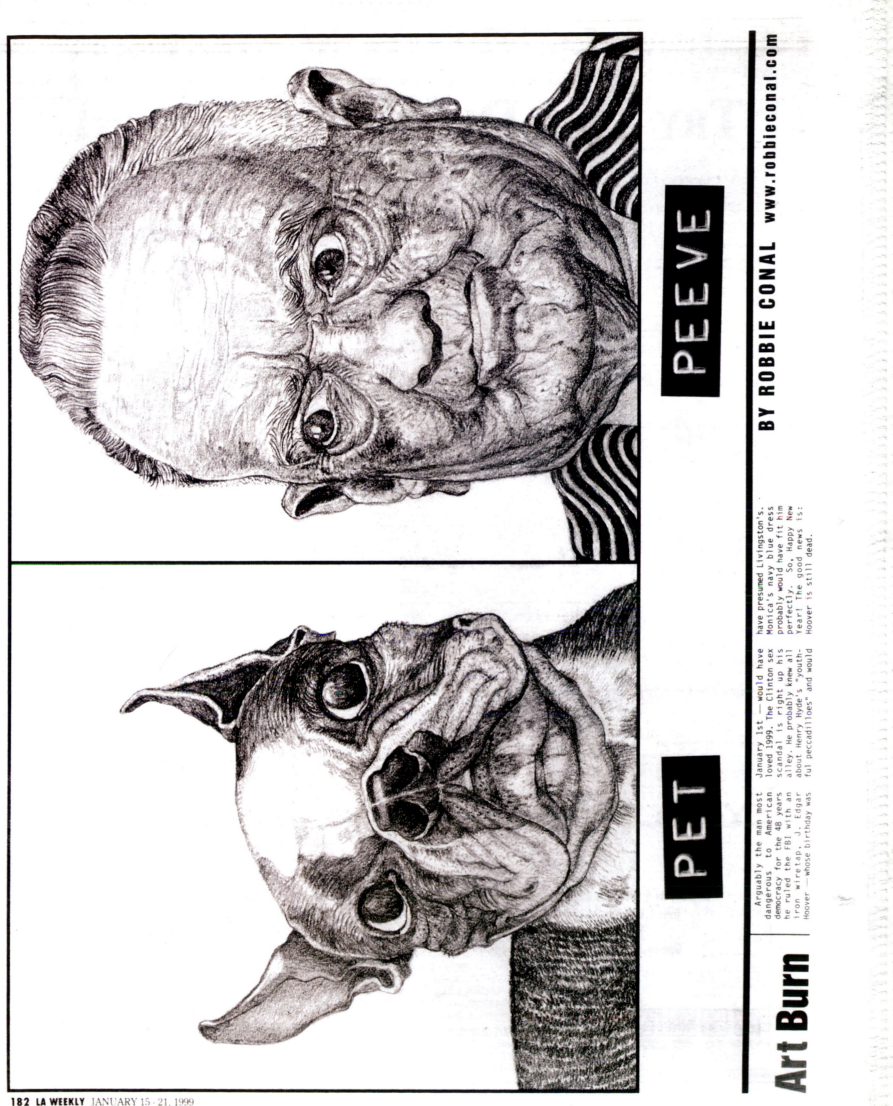

PET

PEEVE

BY ROBBIE CONAL www.robbieconal.com

Arguably the man most dangerous to American democracy for the 48 years he ruled the FBI with an iron wiretap, J. Edgar Hoover —whose birthday was January 1st — would have loved 1999. The Clinton sex scandal is right up his alley. He probably knew all about Henry Hyde's "youthful peccadilloes" and would have presumed Livingston's. Monica's navy blue dress probably would have fit him perfectly. So, Happy New Year! The good news is: Hoover is still dead.

Equality of Life

I remember Rudy. The old Rudy–before 9-11, before he became a secular saint. When Rudy treated the poor of New York like dogs in need of obedience training. He cut social services and medical assistance, eviscerated the public education budget, and promoted a cruel "workfare" program for single mothers (who couldn't even afford child care). How about no more methadone programs? That made those junkies squirm. Then "Saint Rudy," *Time* magazine's "Man of the Year" in 2001, turned his police force loose on the underclass. Anyone still remember Abner Louima? As John Leonard put it, "Crime is down, unless you count police brutality."

I'd done a poster sending up Los Angeles Mayor Dick Riordan for spending a billion dollars on a sinkhole of a subway system, "Tunnel Vision." But I grew up in Manhattan and my friends were pissed: "How can you do a poster about your cute little millionaire mayor and not do Rudy? What kind of New Yorker are you?" They whined about it for two years. So, when Rudy finally outlawed gum-chewing and arrested a journalist for putting up a "Giuliani is a Jerk" sticker on a lamppost–hey, that's a little close to home, even for me in LA!–I was ready to make him my throwback to the 1950s–*Anti-Life* magazine man of the year. Nobody was more fun to draw!

But the joke was on me. First, when we turned this ARTBURN into a poster (adding a Colonel Clink monocle)–just for use in New York, by the way–most of my friends were too scared of Rudy to put the damn thing up on the streets. Second, Rudy's Mussolini complex actually worked during the terrible crisis that was 9-11. He did so well by the people of New York that after 9-11 he became a national hero.

Equality of Life
(Pictured:
Rudy Giuliani)

*My apologies and sincere thanks to John Leonard for basically plagiarizing his great article.

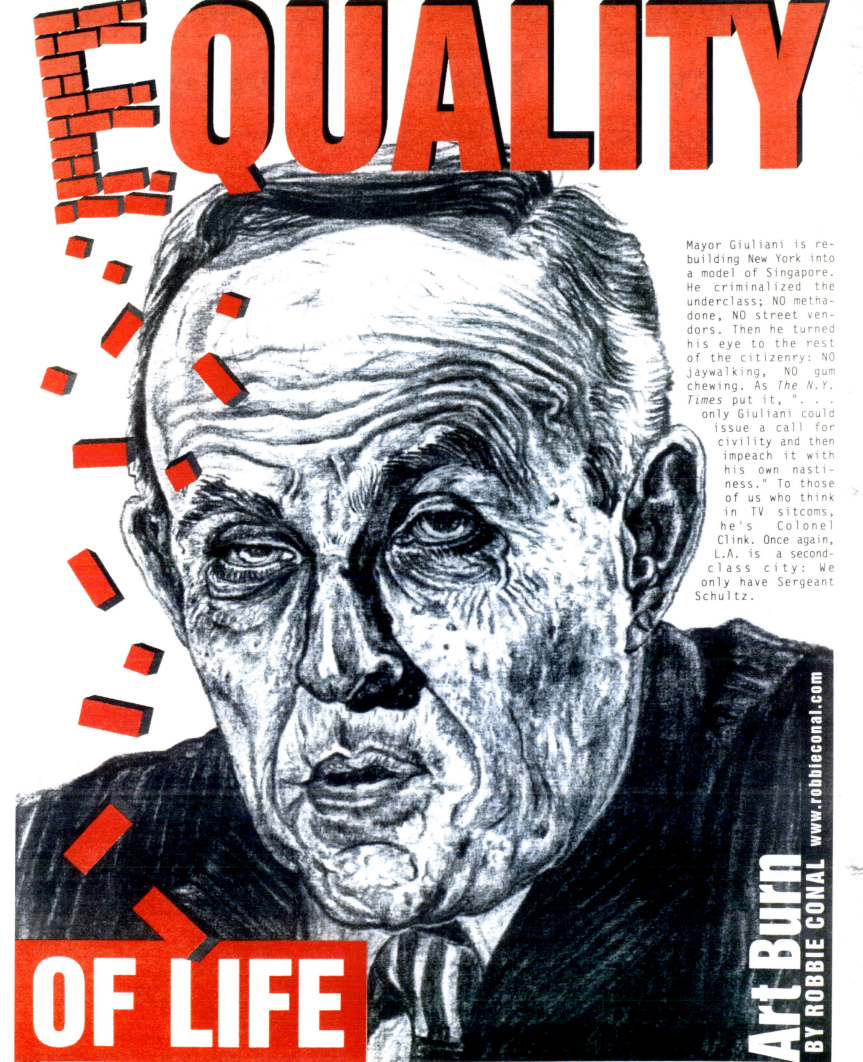

EQUALITY

OF LIFE

Mayor Giuliani is re-building New York into a model of Singapore. He criminalized the underclass; NO metha-done, NO street ven-dors. Then he turned his eye to the rest of the citizenry: NO jaywalking, NO gum chewing. As *The N.Y. Times* put it, ". . . only Giuliani could issue a call for civility and then impeach it with his own nasti-ness." To those of us who think in TV sitcoms, he's Colonel Clink. Once again, L.A. is a second-class city: We only have Sergeant Schultz.

Art Burn BY ROBBIE CONAL www.robbieconal.com

> **"*I had only seen him on TV and I never thought of him as attractive...With his big red nose and coarse, wiry-looking gray hair, he's an old guy. There were tons and tons of women in the White House with crushes on him and I thought, 'These people are just crazy. They have really bad taste in men.' I mean, girls my own age were saying that this old guy was cute, that he was sexy. I thought, 'Gee, this place is weird. What's wrong with Washington?'*"**
>
> —Monica Lewinsky, as quoted in *Monica's Story* by Andrew Morton

Monica, 90210

Washington is weird, yes. Weirder than Beverly Hills....maybe. What's wrong with it? Now, there's a good question.

Monica went to Beverly Hills High School, but her morals seemed to have come from the teen soap opera, *Beverly Hills, 90210*. Maybe she confused the two. Maybe that's the whole idea: It's the same. Instead of having sex with your teacher (she did that already), you're having sex with the president. Oops! Well, she was still very young and he was very powerful. Has anyone done a Zeitgeist check lately? I just can't blame Monica in that power equation. She's been blamed enough, but it could be just a projection of our own embarrassment that beneath the hypocritical rhetoric, our society really works this way. Including bringing down a president for having a girl go down on him. We're just so full of shit and we know it.

I always thought that Monica would be OK. She'd come out of it with a book deal, celebrity, even career options (though I don't know about that line of handbags). Bill Clinton would suffer more for his peccadillo and bald-ass lying. Now I'm not so sure. Maybe it was me, sitting back and being a cynical old wisenheimer. A culture vulture. Monica was more grist for the satire mill. But as I was drawing her, I got to like her in spite of myself. This is not, as Bill Smith kept insisting, the "before" picture for an orthodontia ad.

Monica, 90210

(Pictured: Monica Lewinsky)

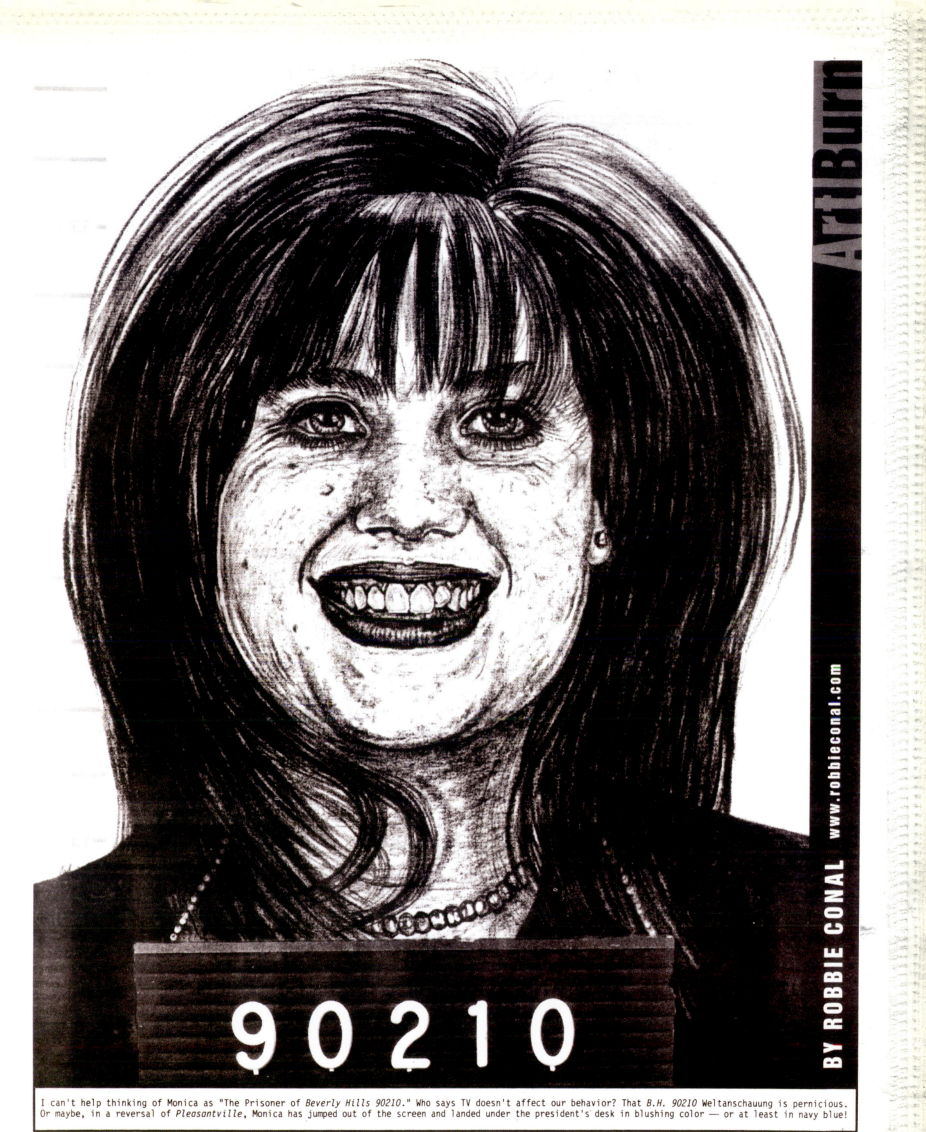

90210

BY ROBBIE CONAL www.robbieconal.com

ArtBurn

I can't help thinking of Monica as "The Prisoner of *Beverly Hills 90210*." Who says TV doesn't affect our behavior? That *B.H. 90210* Weltanschauung is pernicious. Or maybe, in a reversal of *Pleasantville*, Monica has jumped out of the screen and landed under the president's desk in blushing color — or at least in navy blue!

I Am You

Linda Tripp, a.k.a., "The Trapper," not only turned over evidence, she delivered illicit beaver pelts to desperately frigid fish and game wardens. Thus warming the cockles of their . . . well, let's just say, implications. Here's the way I set it up when I talk to high school students (I know, I know, that's a scary thought) about the Bubba-Kenny-Monica-Trapper soap opera. I just wade into the audience, pick out a couple of young women—one to "play" Monica, one to be, ugh, "Linda"—and go into my rap:

Let's say you're a young woman in a new job, having trouble with your boyfriend. Maybe he's a lot older than you. Maybe he's married. Maybe he's the most powerful man on the planet (and the creep doesn't have enough time for the relationship). All these things together could cause you to seek out an older, wiser friend for advice and consolation . . . Uh-oh.

This is obviously a job for an honorable civil servant, doing her sworn duty: Tape record a young woman's most private sexual revelations, while posing as her mature, worldly confidant, and deliver them to a politically blood-thirsty special prosecutor (Kenneth Starr is nothing, if not "special") as well as the rest of the world, so you can entrap the smartest, flawed politician (isn't that redundant?) of our era. It gets some laughs, lots of groans, and the young women eventually get over it.

We haven't heard or seen much of Linda Tripp lately.

Actually, there isn't that much of Linda to be seen. Not since she entered that skin tightening witness-protection program in the basement of the Pentagon.

Linda's job down there must have been quite special as well: "Special Agent in Charge of Delivering Presidential Semen Stains." These days, for all we know, she could be reassigned to pre-digest Dubya's pretzels while he's watching ESPN in the Presidential den.

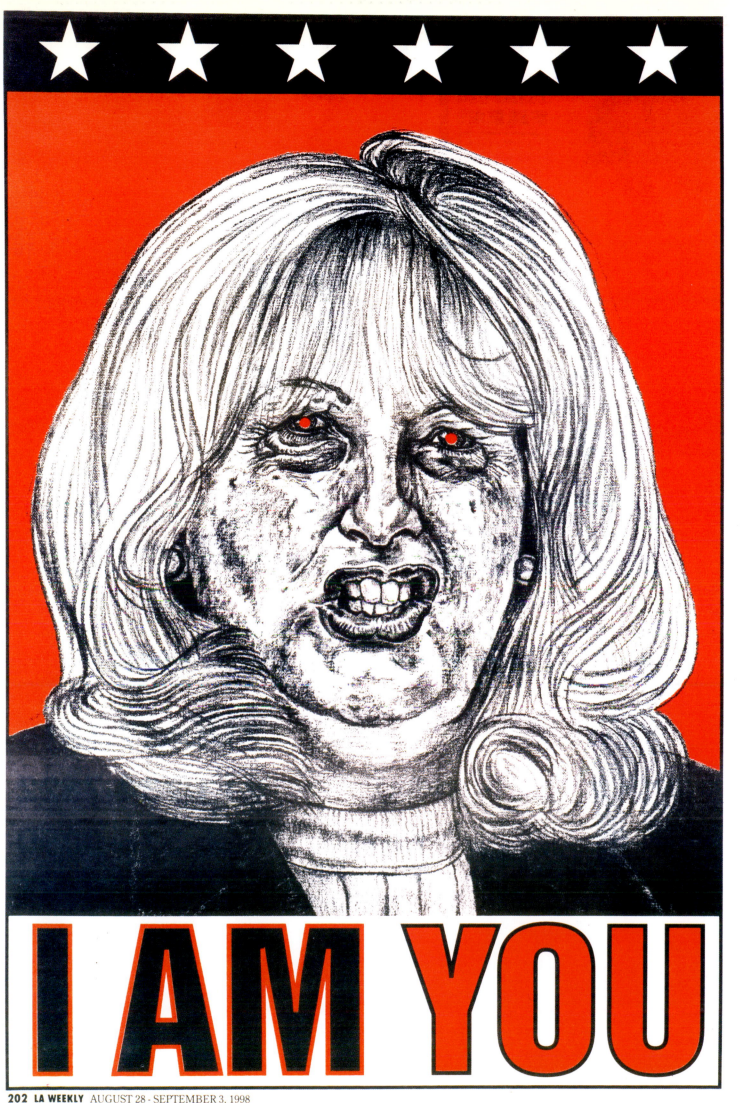

Linda Tripp has already become the ultimate illustration of the saying "With friends like that, who needs enemies?" She's already been given enough tape to hang herself — and everybody else. But does she have what *The New York Times* calls the "genetic material" to prove she is us? That dress is a mess!

I AM YOU

ART BURN BY **ROBBIE CONAL**
www.robbieconal.com

Starrfucker

Theoretical mathematicians say they often know a formula is correct even before they can prove it if its structure is beautiful, crystalline, perfect.

Some public personalities are perfect in the same way. They've been crystallized into icons by the immense pressure of the contradictions of prime-time American culture, where paradox and irony are the truth:

Marilyn. Our All-American sex symbol married all the wrong men, and fucked the president. When she told her psychiatrist her troubles, he advised her to take a relaxing drive on the LA freeways. She committed suicide.

Elvis. Our wonderful white-trash synthesizer of black rhythm and blues and white rockabilly roots music gets trapped and bloated by success. He dies drugged and fat, on the toilet.

Michael Jackson. Our beautiful black baby-boy pop singer flies off to Neverland to become white and sleep with beautiful baby boys.

J. Edgar Hoover. Our WASP bulldog, protector of American values was a revengeful, closeted, self-hating, gay dictator.

Then there's *Bill Clinton* and *Kenny Starr*, two split personalities for the (high) price of one. We got dealt two jokers: double down! The most talented politician of our time, brought down by his weakness for big-haired blowjobs.

" *Well, I try to smile in my daily life...* "
—Ken Starr, interviewed by Lisa Meyers on NBC's *Today*, 8-9-99

Our most sanctimonious special prosecutor blows his own ethics exam. Obsessed by Clinton, Kenny goes J. Edgar on us: putting a wire on Monica's best friend, Linda, dragging Monica's mother in to testify against her, parading Susan McDougal around in leg irons and chains, spending at least $52 million of taxpayers' money. Just look at that face. Who around here is most in need of a blowjob?

NOTE: This piece is a curious instance of freedom of the press being freer than freedom of public space. We had no problem running the "STARRFUCKER" text in the *Weekly*. Sue Horton, the editor, was totally down with it. But when I went to the streets with the poster version, my lawyer advised me that First Amendment free speech protections did not apply to public space when it came to so-called obscenity. Why? It's got to do with freedom of choice: Viewers exercise choice when they open a periodical, but they can't when they're just out on the streets, minding their own business, and get visually assaulted by my ugly old white guys.

Starrfucker

(Pictured:

Ken Starr)

STARR

BY ROBBIE CONAL

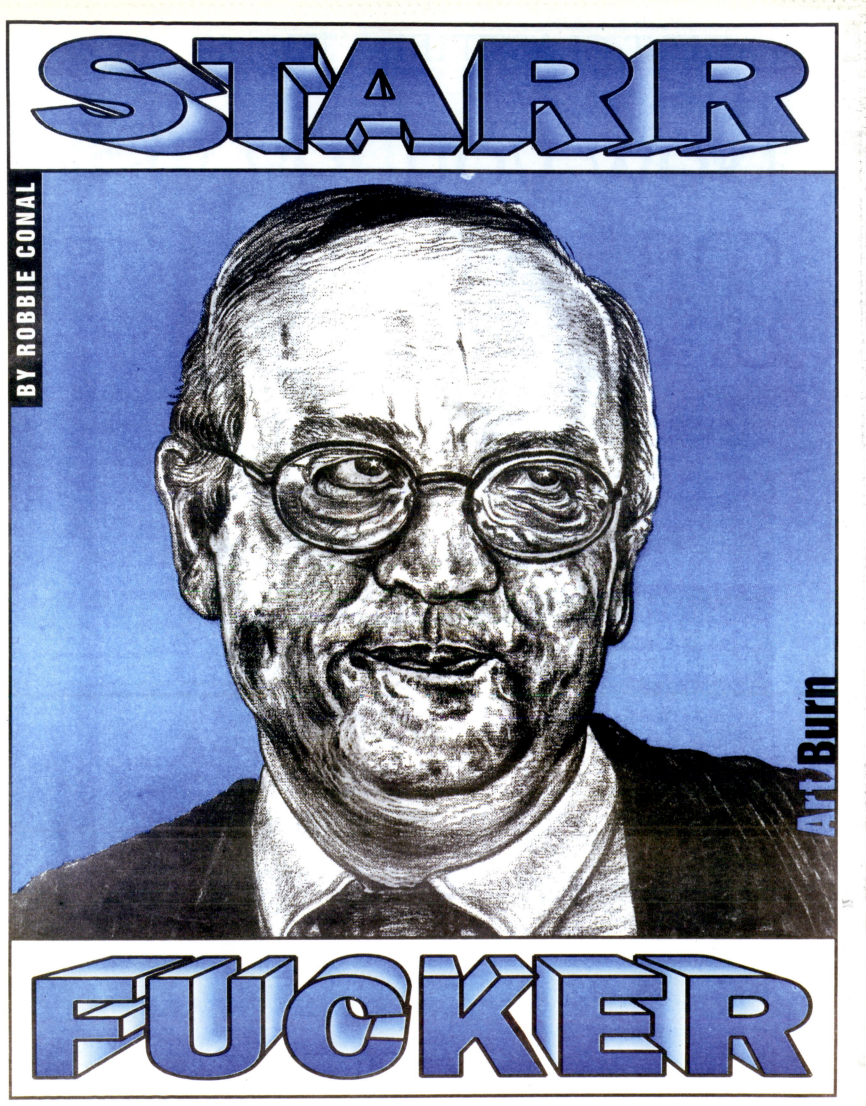

Art Burn

FUCKER

Internal Affairs

Colloquial American English—the language kids speak outside of school, when they're hanging at the mall or on the proverbial corner—is the most subversive form of communication on the planet. Hip hop and rap can shake the language for loose change, you feelin' me, G? Take a bureaucratic meta-linguistic phrase like "Internal Affairs." We all know it from cop shows on TV: the bureau of any big-city police department that polices itself. Whisper it or cackle it on line at a Cineplex, when you're deconstructing Bill Clinton's situation with Monica and you've turned the Oval Office inside out. There's an affair with an intern inside that official lingo. We know that if we were to let Bubba police himself, he'd be inside a lot of interns.

This is a sad little valentine. Sad, not just because sexual power relations in our society are so skewed in favor of powerful, wealthy, old white men, but also because we can let one fatal flaw bring down a great politician and ruin a young woman's life. I never was a big F.O.B.—he's too M.O.R. for me. And too full of bullshit. Running his governmental policies on polling instead of philosophy.

> ## *It depends on what the meaning of the word 'is' is.*
> —Bill Clinton, excerpts from grand jury testimony, 1998

But that's why I do ugly little drawings of powerful people, and Bill's got an office in Harlem.

Internal Affairs

(Pictured:

Bill Clinton)

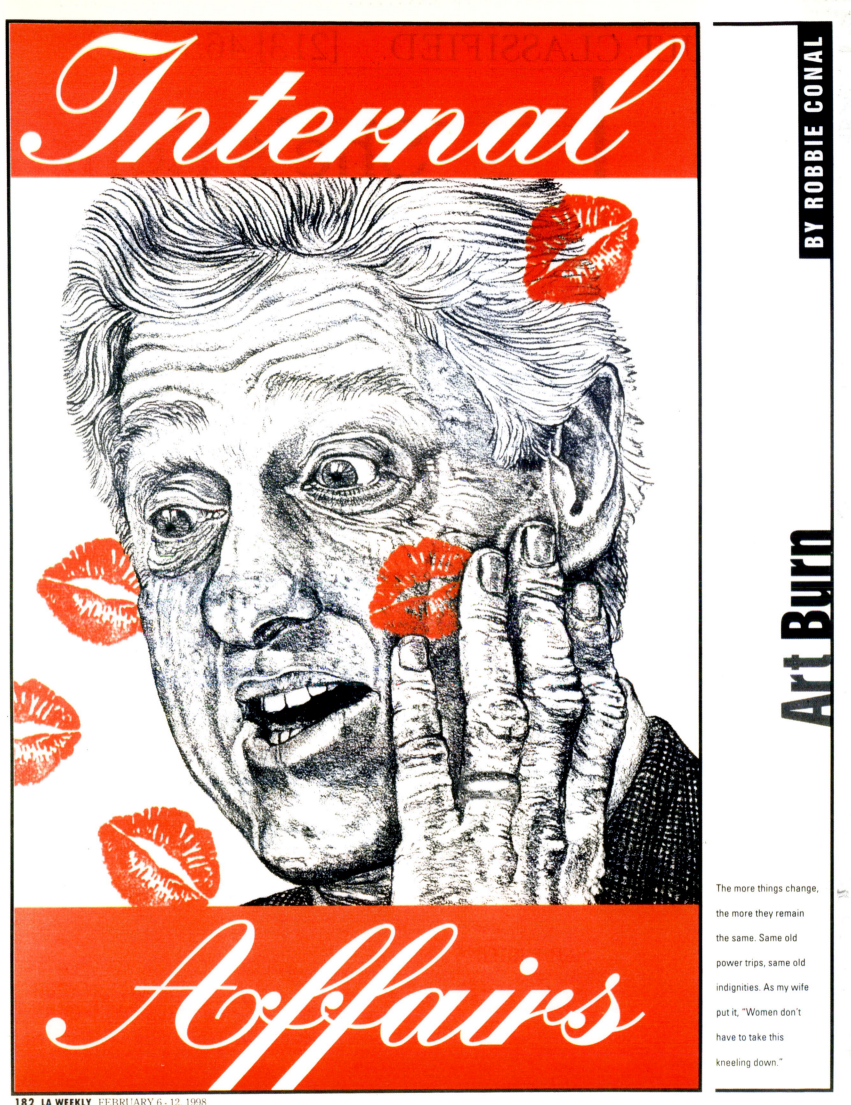

Internal Affairs

BY ROBBIE CONAL

Art Burn

The more things change, the more they remain the same. Same old power trips, same old indignities. As my wife put it, "Women don't have to take this kneeling down."

Anti-Trust Me

Microsoft owns at least 90% of all the computer operating systems in the universe–and Bill Gates is going after that other 10%. Micro goes macro in a big way. The way "Billion Dollar Bill" sees it, sooner or later, everybody's got to pay The Bill. But even if they don't work very well, we have anti-monopoly business-practice laws in this country. So The Bill and his Microgeeks got sued. By the U.S. government, no less. Bill's answer–in his 20-hour, excruciatingly annoying taped testimony, during which he rocked in his chair continuously, knocked down gallons of soft drinks, and parsed words like he was trying to one-up Bill Clinton's disquisition on the semiotics of ethics (see previous page)–was something like, "Trust me."

Which reminded me of money. The basic currency of our capitalist democracy has a pyramid with an all-seeing eye on it and, not exactly separating Church and State, "IN GOD WE TRUST" is engraved on every good old dollar bill. Notice it doesn't say, "IN BILL WE TRUST." Not yet. This is one time I'd be more comfortable trusting God. Anyway, back in the olden days, 1998, I really dug the love that was put into that engraving. Our Bill, the good and gracious Bill Smith, ever indulging my weakness for cheesy Photoshop effects, whipped up some *grand fromage* on deadline. We were going for The Bill's God complex and his life of wealth–to start with, he comes from one of the richest families in the Pacific Northwest–not to mention his all-around hubris. The lame little "ANTI" rubber-stamp effect was the best I could come up with at the time. Sad, but somehow an appropriate comment on my general ineffectualness. The drawing was done to prove that only the richest man in America could afford such a terrible haircut. This was before The Bill's makeover–the fallout from the trial kinda cramped his, uh, style: He lost about $22 billion and had to buy a new suit and get a real haircut.

When I finally got around to re-making this ARTBURN as a guerrilla street poster, Debbie's fabulous designer, Anne Kelly, spent hours souping up the type treatment. We surrounded The Bill's Redmond "campus" and blitzed Seattle streets in the rain. We're big on going from soup to nuts. Though I'm still wondering if the secretaries of government lawyers use Microsoft Word software when typing up attacks on Microsoft. I know I do.

Anti-Trust Me

(Pictured: Bill Gates)

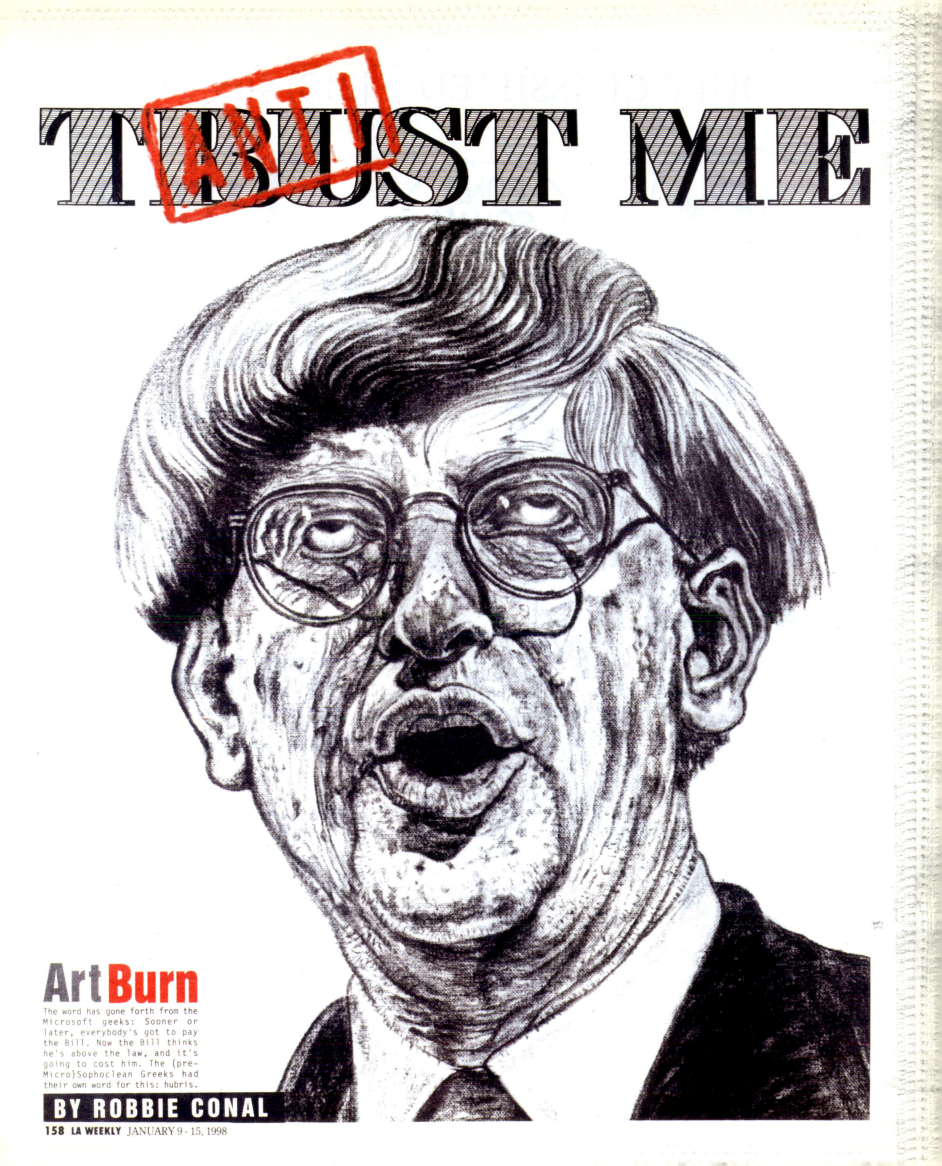

TRUST ME

ANTI

ANTITRUST ME

Art Burn

The word has gone forth from the
Microsoft geeks: Sooner or
later, everybody's got to pay
the Bill. Now the Bill thinks
he's above the law, and it's
going to cost him. The (pre-
Micro)Sophoclean Greeks had
their own word for this: hubris.

BY ROBBIE CONAL

> **"From behind his appearance of pious responsibility and somewhat strained good-fellowship, someone else has looked out at us over the years, with a gaze shrewd, sharp, measuring, menacing to some, enigmatic even to those who believe in him."**
>
> —Tom Wicker, *One of Us: Richard Nixon and the American Dream*

Pet Peeve: Nixon

And that would be: *Checkers.*

The mean-spirited, sneaky back-room dealing of Tricky Dick's trademark realpolitik has haunted my whole life. From his virulent anti-communist support of Whittaker Chambers in the fifties, through the secret bombing of Cambodia, his taping of everyone and everything in the spirit of J. Edgar Hoover, and the Watergate burglary itself, all the way to his ghost inhabiting the body of Kenneth Starr—Richard Nixon has been hovering over my sense of American politics. He's *my* pet peeve.

I do at least one drawing, litho, or painting of Tricky Dick per year. The great American artist Phillip Guston (who spent most of his career as an abstract expressionist) did 72 drawings of Nixon that I know of, but at least I'm gaining on him. While researching my obsession, I stumbled on several photos of Nixon with his famous pet. Not just from the 1952 live-TV "Checkers Speech" that saved his vice-presidential candidacy. Publicity shots from around the White House Christmas tree; the family—Pat, Trisha, Julie, and Checkers—lounging by the fire, romping on the White House lawn, etc. Nixon and Checkers looked exactly alike. I grabbed the photos because I thought they were funny. In the late nineties I had a problem with my right eye. Basically, I couldn't see out of it. No more painting for me. The only thing I could do—professionally—was draw (with my nose touching the paper). So I got out the goofy Nixon/Checkers photos and a pencil, made like Tricky Dick, and sneakily juxtaposed the presidential pet and my presidential peeve.

Pet Peeve

(Pictured:

Nixon and Checkers)

PET PEEVE

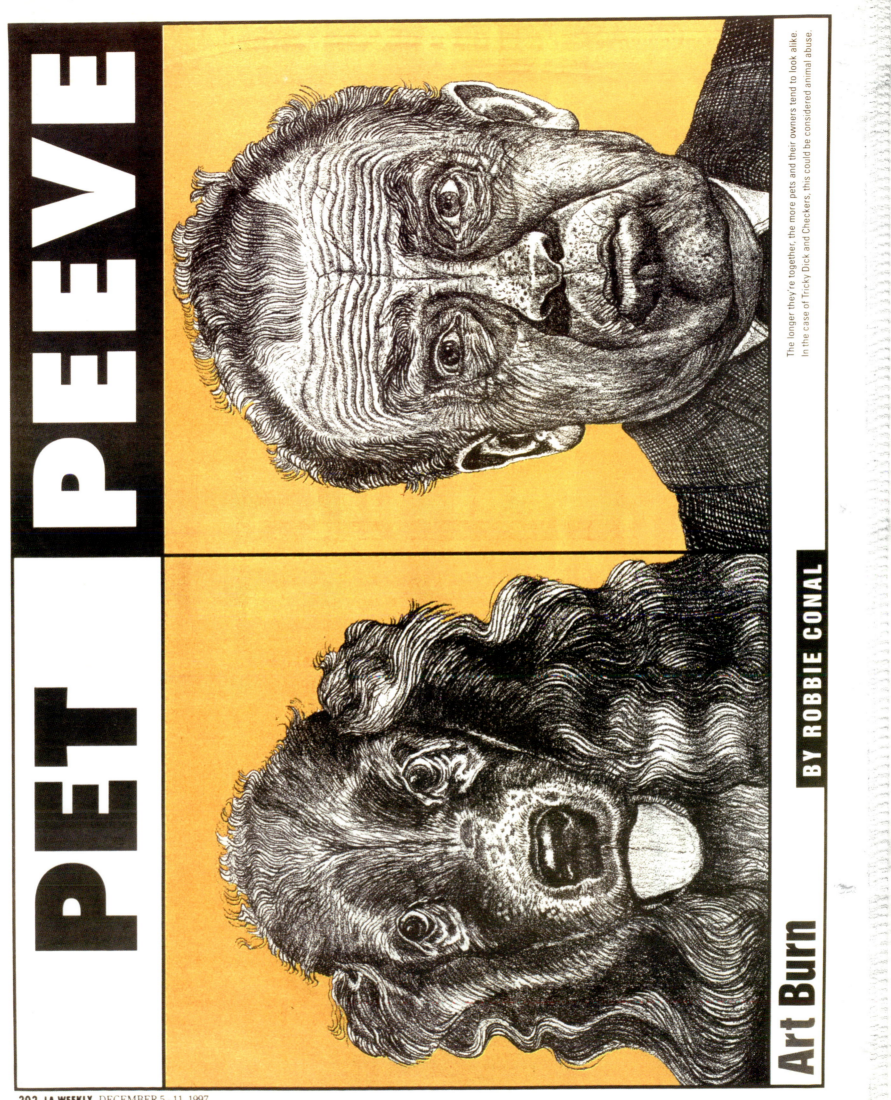

The longer they're together, the more pets and their owners tend to look alike. In the case of Tricky Dick and Checkers, this could be considered animal abuse.

Art Burn

BY ROBBIE CONAL

> **"Tibet has been for hundreds of years part of China. Therefore, the mere raising of an issue that sounds as if we're trying to separate a part of China creates special sensitivities."**
>
> —Henry Kissinger, as quoted in Frontline Online

Mouseketeer

Since Richard Nixon is my evil muse, Henry Kissinger must be the devil, standing on his far right shoulder, whispering into his ear. In the years since the halcyon days of Vietnam and Watergate (Hank did double duty as a prime architect of the overthrow of the democratically elected Allende government in Chile on September 11, 1973–the first 9-11), he's been downright chatty. A major media-sucking political pundit, running a heavy international law firm, weighing in on everything from peace in the Middle East (there is none) to free trade with his old dim-sum-what pals in semi-capitalist China. Which brings us to Disney. In the wake–or blowback–of two anti-Chinese Communist big-budget Hollywood spectacles, *Seven Years in Tibet* and *Little Buddha*, "Mauschwitz" threw down its $100 million *Kundun*, by Martin Scorsese no less. Unfortunately for Disney, they were just about to seal a multibillion-dollar merchandising deal with the Chinese government. That's a lot of Goofy T-shirts, baby.

This is one of my favorite ARTBURNs–I dig the Pepto Bismol-pink Bill Smith laid behind the wily old Mouseketeer. And it was my pleasure to have Henry into the studio to sit for his passport portrait wearing his new hat.

> **"They aren't going to stop that country [China] from having Mickey Mouse."**
>
> —Richard Gere, as quoted in *Business Week*, 11-03-97

Mouseketeer

(Pictured:

Henry Kissinger)

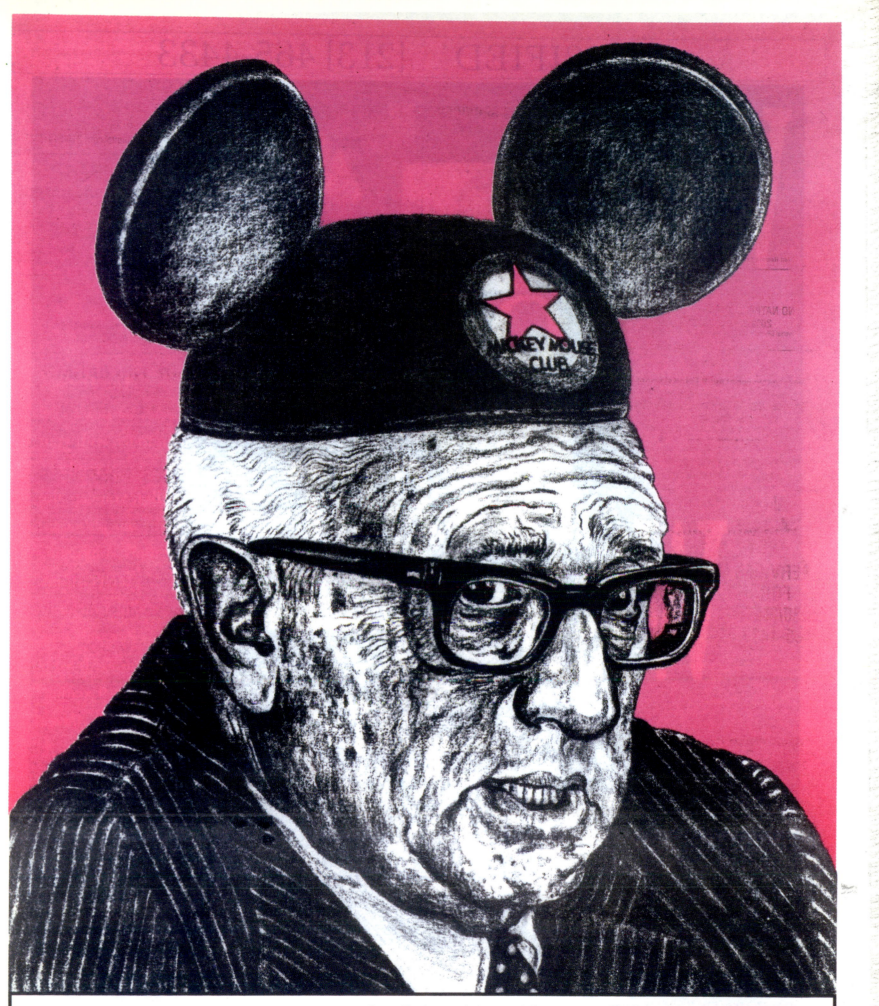

Art Burn

Henry Kissinger, who arranged the secret bombing of Cambodia, initiated the White House tapings in the Nixon Administration (no wonder he's got such big ears) and prayed with Tricky Dick in the Oval Office, is now baby-sitting Disney's multibillion-dollar deals for children's entertainment and sports programming in China.

The Chinese government is upset about the trashing of China's invasion of Tibet in the forthcoming Disney-financed film *Kundun*. So send in the mouse that roared!

BY ROBBIE CONAL

" *In FBI interviews, Vice President Al Gore changed his answers when confronted with documents in a fundraising investigation, and suggested he may have missed a key discussion during a meeting because he drank too much iced-tea."*

—Pete Yost, "Gore's Iced-Tea Defense," Associated Press, 2-12-12

Dough Nation

That wild and crazy guy! Speaking of crazy, there are three things Americans are crazy about: private property, sex, and money (not iced-tea). Every American knows the country runs on money. Including its politics. And the Boy Scouts. (The Girl Scouts sell cookies, the Boy Scouts sell adolescent militaristic patriotism.) We're a DOUGH NATION (there are more words for "money" in colloquial American slang than any other word in English) . . . and "following the money" is the way to find out about everything.

It's possible that Clinton and Gore raised around one million dollars from their billet in the White House.* There's nothing wrong with raising money for your political party. It would be un-American not to. But the president and vice president inhabit the White House because they supposedly represent the whole country, not just one party.

So when the biggest Boy Scout, Al Gore, made at least 75 fundraising phone calls from the White House to prospective democratic donors, there was a chance he violated an 1883 law forbidding political fundraising on government property. Not to mention the spirit of the enterprise, democracy.

Actually, by the mid 1990s, campaign finance laws were so loose that Clinton strategist Slick Dick Morris said, "It takes real talent to do something illegal under these laws." He should know.

It's comforting for us to be told that Al has real talent. I had my doubts when he was asked about his illegal fundraising jaunt to the Hsi Lai Temple in Hacienda Heights, California. A $2,500-per-person affair. Al said, "I didn't realize I was in a Buddhist Temple."

Scout's honor, Al?

*Speaking of following the money, the Democratic National Committee, at Gore's insistence, reimbursed the Federal Treasury for $24.20 for the cost of 20 fundraising calls not charged to campaign credit cards. You go, Al! Source: Marc Lacey, *Los Angeles Times*, 7-27-97.

Dough Nation

(Pictured:

Al Gore)

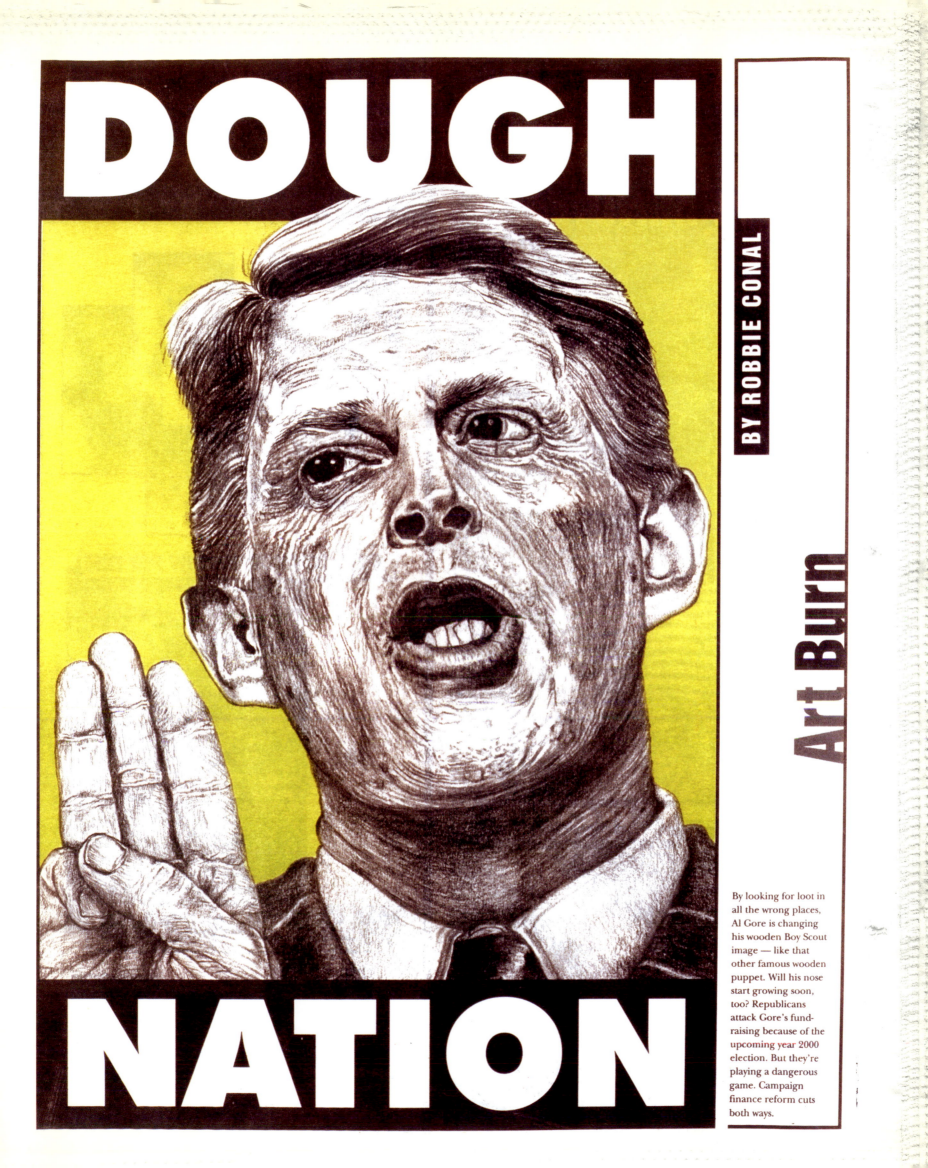

DOUGH

NATION

BY ROBBIE CONAL

Art Burn

By looking for loot in all the wrong places, Al Gore is changing his wooden Boy Scout image — like that other famous wooden puppet. Will his nose start growing soon, too? Republicans attack Gore's fund-raising because of the upcoming year 2000 election. But they're playing a dangerous game. Campaign finance reform cuts both ways.

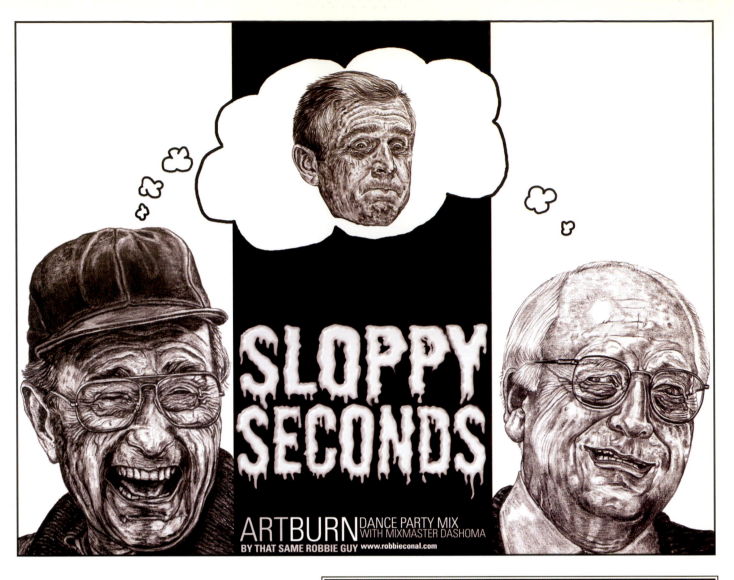

Remixes

Working in my studio or down in the *Weekly's* Bat Cave, I always had too many ideas, or just couldn't stop riffing. When it was good, it was like jazz: establishing a melody, usually an old standard (like a charcoal drawing of another ugly old white guy, text above, text below), then noodling away from it as the deadline pumped up my adrenaline. When we turned the computer-graphics wizards loose–Bill was Master Po, I was Grasshopper; even 21-year-old Chuckles was dropping bombs on me–it became more like hot young DJs remixing an old man's repertoire. The language comes with the territory. Obscene abuse of power, failure of nerve, and nepotism by wealthy politicians and bureaucrats who supposedly represent us, inspired an ironic, rueful "street" scatology in the Bat Cave.

This page:
Pictured: (Top) Bush Sr., Dubya, Dick Cheney; (Bottom) Trent Lott
Opposite page:
Pictured: (Clockwise) Colin Powell; John Ashcroft; Al Gore; Colin Powell

"The past is never dead. It's not even past."
— William Faulkner

BY ROBBIE CONAL.

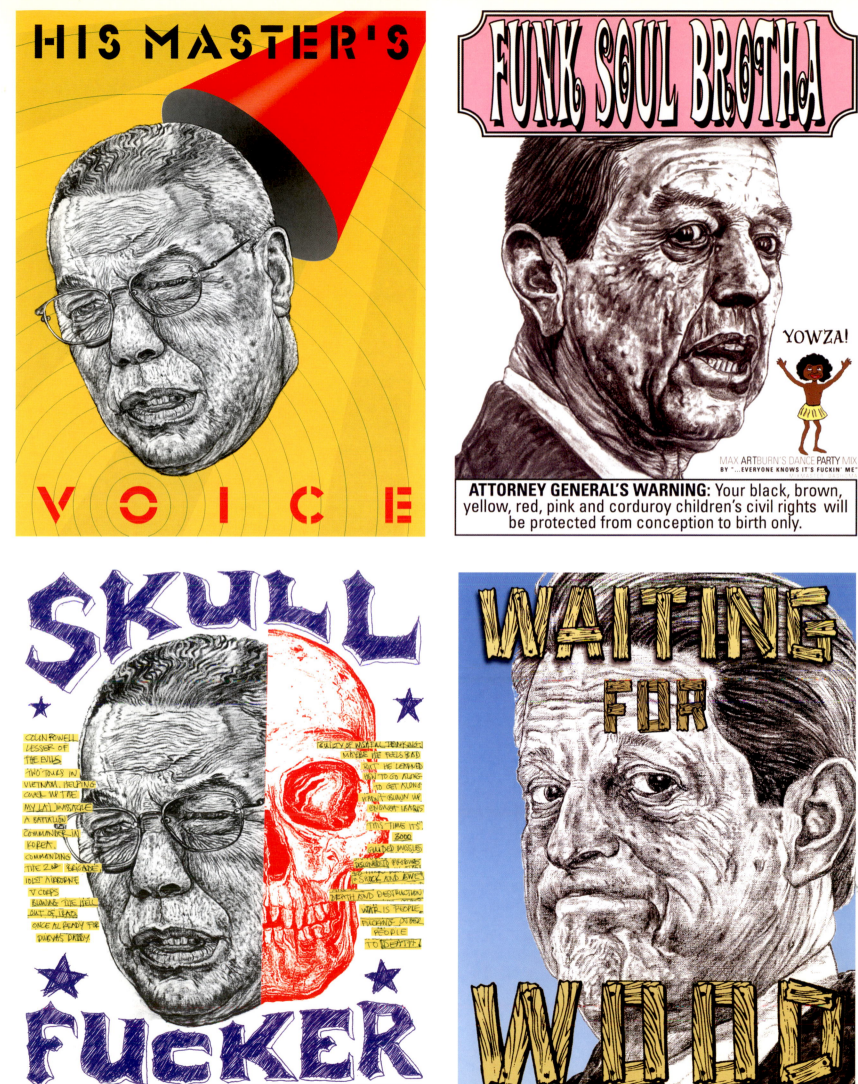

Covers

In 1996, when I could only see with my left eye, Sue Horton asked me to do a cover of Pat Buchanan. I'd already drawn him—maybe that's what was wrong with my right eye, he was stuck in it. I just added a lovely razor barbed-wire halo—something about Buchanan's position on immigration—and Bill Smith finessed that irradiated background. By Independence Day 2001, I had a new bionic eye, but Uncle Sam was blowing a fuse. These days, Uncle has other problems—it's the post-war economy, stupid!—and this cover has taken on new meaning. Not to mention the problems the big guy had during the 2000 presidential election. Something about democracy, and I don't mean the Democrats. They had their own problems, however. When they came to Los Angeles for their convention, the *Weekly* went daily, and so did I. Five covers in four days. Tipper had her own pull-out section on Al's day—You go, grrrrl! She's such a rocker. (Or just off her meds.)

If he ever dares to run for national office again, I'm planning to recycle that Lieberman drawing. Which party is this guy working for? Does it matter? That's really the point of this whole enterprise. Democracy matters.

This page:

Pictured:
(Clockwise) Pat Buchanan; Uncle Sam; Gray Davis

Opposite page:

Pictured:
(Clockwise) Al Gore; Joe Lieberman; Bill Clinton; Tipper Gore

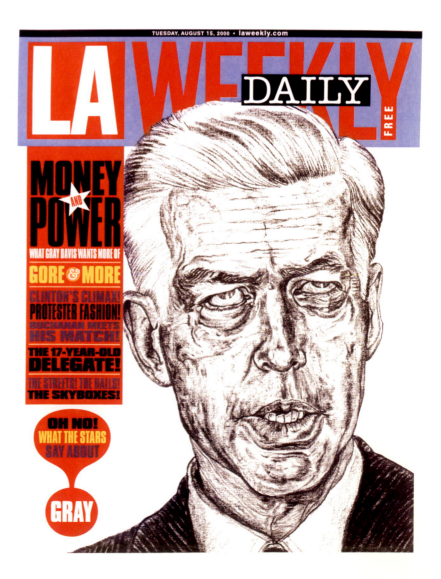

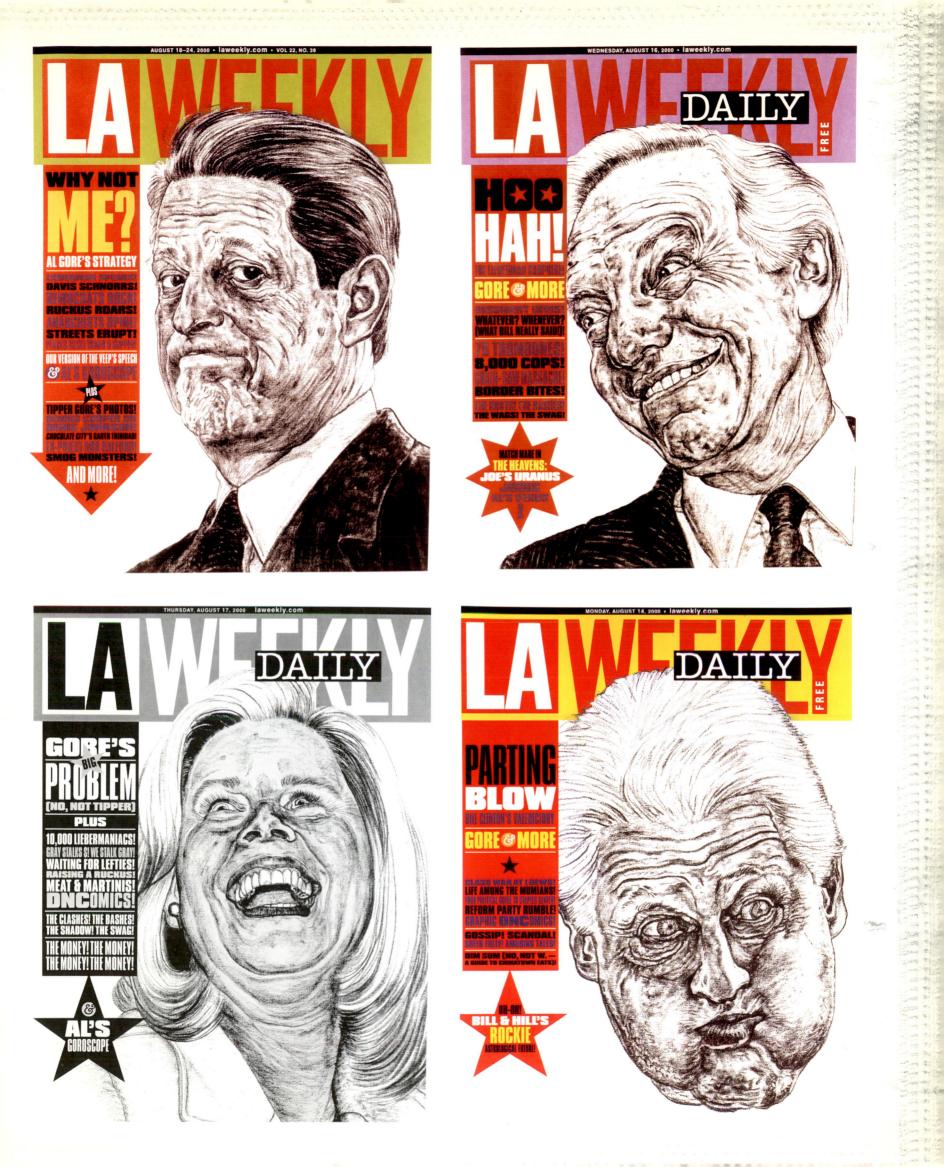

Slow Burn, the Posters

These street posters are either remixes of ART-BURNS or recycled cannibalizations. They're "slow burns." Issues and images that just wouldn't go away–got worse, in fact. I might have overcooked the art, but the posters came out hotter and, arguably, angrier than the ART-BURNS.

For "Secretary of Offense," I recycled the "Enronergizer Bunny" drawing of Dick Cheney as "Mini Me," adding him to Donald Rumsfeld's "Dr. Evil." Those fictional characters have nothing on Dick and Rummy when it comes to their designs on world domination. Remember the question, "Why do they hate us?" The little bling-bling rings refer to their not-so-secret society. I imagine that Paul Wolfowitz and Richard Perle are wearing their rings right now. Oh, by the way, after Iraq II, who hates us now?

"Tower of Babble" is a text extravaganza, based on all the Homeland Security propaganda bullshit being dumped on us by Dubya's min-isters of surveillance and disinformation. We added a little Enron energy and pumped up Ashcroft's head in accordance with his sense of self-importance.

"The Second Scumming" recycles Bush Senior from a poster triptych I did in 1989, "Sex, Drugs, Rock & Roll" (he's "Drugs"). That bug-eyed Dubya comes from . . . well, it comes from "Hail to the Thief," which was originally an illustration for *The Nation*. I really disliked that text–thought it was too easy–but Katrina van-den Heuvel, the Editor in Chief, talked me into it. To my chagrin, people kept asking for "Thief," thinking it was a poster, so I finally gave it to them. So I was wrong, again. For good measure, that Dubya drawing also turns up in "Spoiled." As for "Scumming," I regretted not oozing that oily type across the whole piece in "Spoiled." I finally got myself to kind of do it.* I'm still a design chicken though: I just couldn't drip the shit all over their ugly mugs.

Opposite page:

Pictured: (Clockwise) **Hail to the Thief,** Dubya, 1-20-01; **Tower of Babble,** (from top to bottom) John Ashcroft, Tom Ridge, Dubya, 3-19-02; **The Second Scumming,** (from left to right) Bush Sr., Dubya, Dick Cheney, 2-14-01; **Secretary of Offense,** Donald Rumsfeld, Dick Cheney, 9-3-02

*Thanks to Castle Signs in Santa Monica, and their great surfing sign painter, Alan Thompson.

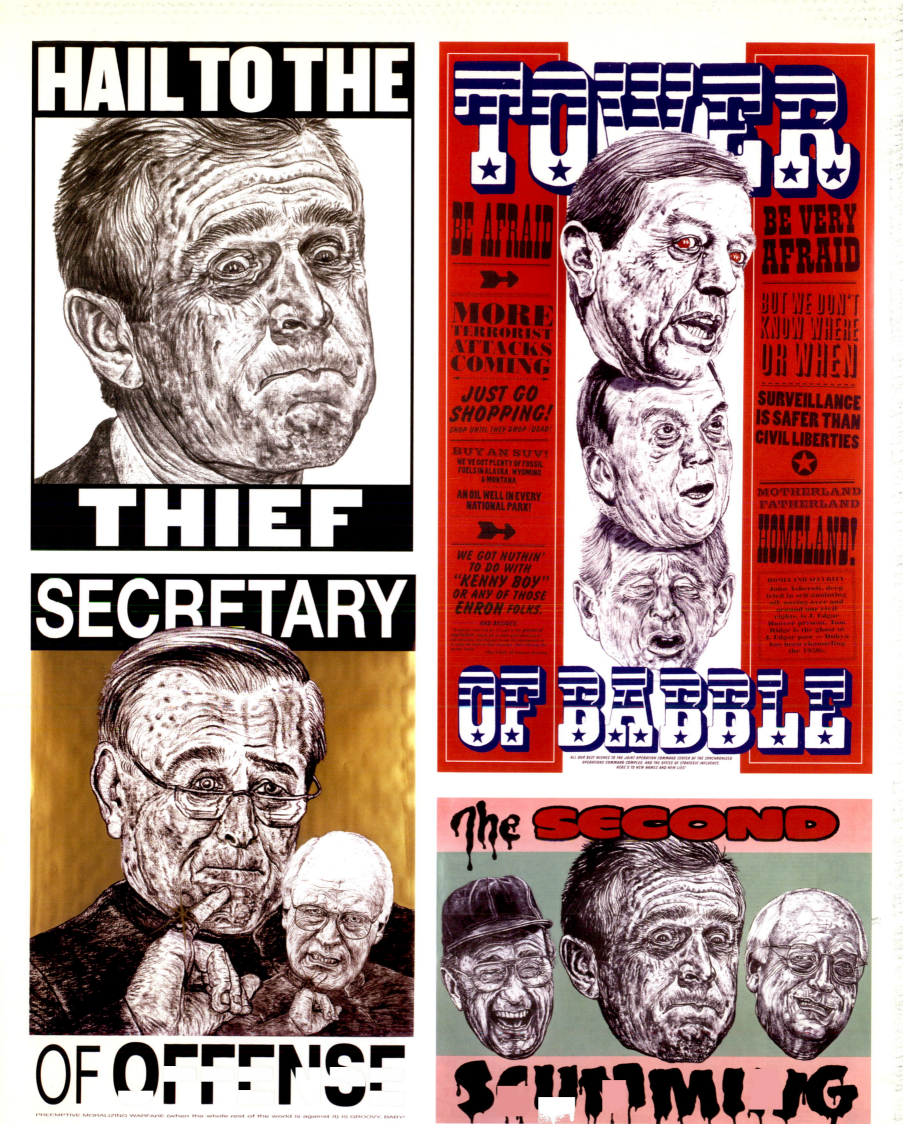

ACKNOWLEDGMENTS

EVEN THOUGH I MOSTLY SIT IN MY ROOM AND PLAY

with my crayons, anything else I do in relation to art-making involves the cooperation and patience of many people. For instance, I know nothing about what goes into making a periodical or preparing a graphics page for print. Cut-and-paste collage has gone the way of the Stone Age (which is where I'm coming from). Thanks to the folks at the top of the *LA Weekly*: Sue Horton, Laurie Ochoa, Tom Christie; and in the Bat Cave: the ineffable Bill Smith, indescribable Dave Shulman, subsonic Dana Collins, Tulsa Kinney, Laura Steele, Fiona (the goddess of color), and above it all, in my book, Sheryl Scott. In the studio: my glittery assistant Boom Boom (and her man, Blondie) and mah bunnies: Bambi, H-Bomb, Mix-Master Chuckles, Eric, Ryan, and Molly (though she still hasn't played the electric saw for me). In the real world: our tigress-mother lawyer Susan Grode, Howard Zinn (one million books, oh, my god!), Steve Heller (who knows everything about graphics and, charmingly, nothing about baseball), Robert Greenwald and Danny and Victor Goldberg, who made this book possible, and Johnny Temple, our extraordinary, multitasking, rock'n'roll publisher. (Special thanks to Johanna Ingalls, too!) I'm indebted to all the great investigative reporters I've stolen from and the blogging conspiracy theorists who have to be right some of the time. Janeane Garofalo is my hero. David Arquette adds a breath of fresh air to my art cave. Nothing stops the irrepressible Paul Alan Smith (and Flavia!) and the unsinkable Holly Jones and her Grrrrlz Jeni (she's uncanny) and Lisa at Wide World Photo. Then there's the putative mayor of Venice, Al Shaffer, photographer extraordinaire, 24-7. The glamorous Anne Kelly, Debbie's talented designer, adds very necessary lipstick feminism to the mix. Beverly Laxa rocks (thanks, Marilyn!). When I needed them, Steve Ross gave me "real" facts, and Steve and Cindy Vance provided "comix relief." My special gratitude to Penny Jones, Admissions Director for the USC School of Fine Arts, for introducing me to every arty high school student in the greater LA area (thereby keeping me close to hip); and her tag-team partner in USC Fine Arts Advising, Christina Aumann, for all the great yakking (you know what I'm yakking about). Mari Masoaka and Connie Julian–for keepin' it red, er, real. Nancy Wren, Jamie Otis, and Brian Kearney for believing and keeping me solvent. Mike Feeney is my panoptically paranoid alien Don. I love you Sue Coe. To Leon Golub and Nancy Spero, my "art-mom and dad," as always. The Guerrilla Girls are inspirational. Of course, there's always music: Thelonious Monk, the Ho'opi'i Brothers and Ledward Kaapana, the Swan Silvertones, Orchestra Baobab, and LA's finest–the ever-awesome Ry Cooder, Tom Waits (don't be picky, he's ours!), the Latin Playboys, and Ozomatli. Jerry Quickley and Mystic are beautiful spirits. So are Richie Montoya and Culture Clash. There's no art without baseball! (I love to watch the Yankees play, especially when Boomer's pitching–in spite of myself and George Steinbrenner. The Cubbies are going to be fun to watch with Dusty on the front step of the dugout. And thanks to the Angels for that sixth game!) And the Lakers. Also, Dan "the Man" Bradlow. I'm grateful for all our furry friends: Goddess, Smilla, Boudou, Cole, Patt, and Herbie. I'm sure I've left out the names of many wonderful people. Please forgive me–I'm half brain-dead right now. Finally, there would be no book, no love, no me without my quiet riot, the wondrous Debbie Ross. Thank you all.

–ROBBIE CONAL

My wonderful assistant, Elizabeta. Now you know why she's called Boom Boom!

Alan Shaffer and Boom Boom.

Smilla and Goddess helping the Art Director.

Debbie, Anne, and Cole: you call this designing?